CW00927911

PADDY
ROSSMORE

PHOTOGRAPHS

The photographer and author wish to thank sincerely
Helen and Michael Roden
for their generous support of this publication.

PADDY ROSSMORE

PHOTOGRAPHS

Edited by ROBERT O'BYRNE

THE LILLIPUT PRESS DUBLIN

ACKNOWLEDGMENTS

I would like to say a 'thank you' to Robert for suggesting the idea of this book
in the first place. Also for all the work he has done in furthering the project,
not to mention the wonderful texts accompanying each photograph describing
the history and architecture of each building.—Paddy Rossmore

Thanks, also, to the staff of the Irish Architectural Archive.

First published 2019 by
THE LILLIPUT PRESS
62–63 Sitric Road, Arbour Hill
Dublin 7, Ireland
www.lilliputpress.ie

Photographs © 2019 Irish Architectural Archive, Dublin; Paddy Rossmore
Text © 2019 Robert O'Byrne; Colum O'Riordan

ISBN 978 1 84351 768 9

A CIP record for this title is available from The British Library.

10 9 8 7 6 5 4 3 2 1

The Lilliput Press gratefully acknowledges the financial support
of the Arts Council /An Chomhairle Ealaíon.

Set in 12 on 17pt Bembo Pro by Niall McCormack
Printed in Spain by GraphyCems

CONTENTS

THE PADDY ROSSMORE COLLECTION

In April 1974 a photographic exhibition entitled *The Architecture of Parnell Square* was held in the Exhibition Hall of Trinity College's New Library. The images revealed to a responsive public the extraordinary decorative wealth behind the severe façades of the Square. When the exhibition was over, there was no obvious place where these photographs could be placed so that they might continue to be accessible to the public, no Irish equivalent of the National Monuments Records in the UK or the Historic American Buildings Survey, no repository or archive dedicated specifically to recording Ireland's buildings. In response to this absence, in 1975 Edward McParland and Nicholas Robinson published a report entitled *The Case for an Archive of Photographic Material,* the central tenet of which was the belief that 'a national architectural photographic archive is one of the essential cultural institutions of any country'. The following year, 1976, the Irish Architectural Archive was established.

While the holdings of the Archive have, almost from the start, expanded beyond photographs to include records of every kind relating to the architecture of the entire island of Ireland, photography remains centrally important. There are now more than 500,000 photographic images in the Archive's collections, ranging from the mid-nineteenth century beginnings of photography to high resolutions digital images. The Archive maintains a continuing record-photography programme that is complemented by extensive holdings of historic images and collections of photographs taken

by individual architectural photographers. Of singular importance amongst these is the Paddy Rossmore Collection.

Acquired in 1980, the Rossmore Collection comprises several thousand black and white negatives of photographs of buildings across the length and breadth of Ireland taken from the early-1960s to the mid-1970s. A number of factors make the collection particularly significant. Firstly, the buildings, whether readily recognizable or hidden gems, are invariably architecturally noteworthy. Secondly, in very many cases and in particular for country houses, coverage includes not only the exteriors but also the much less readily accessible interiors. This is a clear tribute to Paddy's charm when engaging with building owners to secure access. Finally, there is the composition. Each shot is meticulously crafted to create not only a record of a particular structure but also an object of beauty in its own right. Cumulatively, Paddy Rossmore's photographs bear eloquent testimony to the communicative power of the photographic image to reveal not simply the form but the personality of buildings.

Colum O'Riordan
CEO, Irish Architectural Archive

Now in the care of the Irish Architectural Archive, Paddy Rossmore's photographs provide an invaluable account of Ireland's architectural heritage just at the point when, after decades of neglect, its importance was beginning to be appreciated. At the start of the twentieth century, the Irish Georgian Society, in its original incarnation, had photographed and commissioned drawings of many old houses in Dublin and elsewhere. There then followed a long, fallow period. Prior to Paddy, only a handful of individuals such as Maurice Craig had taken the trouble to create a visual record of the country's historic buildings. Today these images are greatly prized, since much of what they show has been lost. The same is true of Paddy's collection of photographs, although happily in a number of instances buildings that he photographed in a poor state of repair have since been restored. Some of these are included here.

Embarking on a photographic career just a few years after the Irish Georgian Society had been recreated and re-energized by Desmond and Mariga Guinness, Paddy had the good fortune to be the right man at the right time. Born in February 1931, William Warner Westenra, always known as Paddy, is the son of the sixth Baron Rossmore whose Dutch forbear moved to Ireland in the early 1660s and settled in Dublin. The family eventually came to own a substantial estate in County Monaghan where, in 1827 the second Lord Rossmore commissioned from architect William Vitruvius Morrison a large neo-Tudor house called Rossmore Castle: in 1858 the building was further extended in the Scottish baronial style by William Henry Lynn. It is said that

a competition between the Rossmores and the Shirley family of County Monaghan over which of them owned the larger room meant that the drawing room in Rossmore Castle was enlarged five times. Famously the building ended up with three substantial towers and 117 windows in 53 different shapes and sizes.

By the time Paddy was a child, Rossmore Castle was in poor condition and suffering from rampant dry rot: mushroom spores were found sprouting on the ceiling of the aforementioned drawing room. In 1946 the family moved to Camla Vale, a smaller house on the estate, and the remaining contents of Rossmore Castle were offered for sale. The building was eventually demolished in 1974. Meanwhile, following the death of his father in October 1958, Paddy inherited what remained of the property: he had graduated from Trinity College, Cambridge, the previous year. Like many young men then and now, it took him some time to decide what he wanted to do next. In 1962, having recently sold Rossmore Park with its farm and forestry, Paddy moved into a flat in Dublin's Merrion Square and took up photography. 'In order to train for my new work I joined Desmond Williams, a New Zealand fashion photographer who had his studio and darkroom in Baggot Street. I never expected to become a fashion photographer. In fact, being shy I was never good at photographing people, where you need the ability – which I have always lacked – of being able to do two different things at the same time, keeping people relaxed with talk while attending to camera settings.'

Paddy gradually acquired the necessary technical skills, and this was noticed by an old friend, Desmond FitzGerald, the Knight of Glin. At the time Desmond was trying to complete his doctoral thesis on Palladian architecture in Ireland, and lived in a little house tucked behind Leixlip Castle, County Kildare, home to

Desmond and Mariga Guinness. As founders of the Irish Georgian Society in 1958, the Guinnesses were passionate advocates of the country's architectural heritage, and keen to discover more of it. Their enthusiasm for the subject was soon shared by the Knight, who in turn sought to engage Paddy. Having learnt the secrets of the darkroom, 'I realized there could be an opening – which appealed to me – when Desmond asked would I come with him to the west of Ireland and we photographed things there, follies and old buildings and so forth.' The photograph of the temple at Neale Park, County Mayo, was one of the first that Paddy took on that trip and printed up. 'When I showed Desmond the results he was pleased with what I'd done. Architecture wasn't at all my subject, I just photographed what I was told.'

Other expeditions with Desmond followed, often in the company of Mariga Guinness, and pictures taken on some of those trips are included here. Paddy remembers how on many occasions 'we would go up these drives and then, if the house wasn't right, we'd turn around and drive away and the Knight would shriek, "Failure house, failure!"' Because the Knight and Mariga Guinness decided the itinerary, Paddy's collection of photographs tend to focus on some parts of the country more than others, and there are certain areas entirely unrepresented. 'Usually we were searching for buildings displaying the influence of Palladio, an activity which on a few occasions seemed to me to be a little obsessive when so many beautiful rivers (I'm a fisherman) and views of mountain scenery were bypassed. I got rather tired of going around all these houses – so they called me "Crossmore"!'

Nevertheless, the experience of visiting so many places, and having to capture them on film, provided Paddy with invaluable training. When it came to old houses, he had two advantages: a

naturally sensitive eye, and lifelong familiarity with the subject. Both stood him in good stead, not least because he gained access to properties that might otherwise not have welcomed a photographer. Some of the places visited were already known to him, such as Dunsany Castle, County Meath. The Dunsanys 'were more friends of my sister than me, but I obviously knew them. They used to stay with Henry McIllhenny [at Glenveagh Castle, County Donegal]. I was always an admirer of A.E.'s pictures, and every time they went to stay with him they presented one. I was very impressed.'

Once engaged by photography, Paddy displayed great dedication, especially necessary when taking pictures outdoors in Ireland where the weather can be so volatile. At Powerscourt, County Wicklow, for example, 'it was a terribly gloomy day, but I thought that I'd stick it out. The sun came out for about ten seconds and I got a snap. That's very typical of photographing in Ireland all the time.' Similarly when trying to get pictures of Bantry House, County Cork, 'it poured and poured with rain. Everyone else was frustrated, but I had a rod in my car so I went off fishing in the local river, and caught a salmon.'

By the mid-1960s Paddy's abilities as a photographer of historic buildings had become well known and he was invited to record buildings for the Irish Georgian Society and a number of architectural historians. 'During the years 1966 to 1969 I spent some time in England when John Cornforth, Alastair Rowan, and later Mark Girouard, asked me to do some work for *Country Life* magazine both in England and Ireland.' In 1966 the solicitor Charles Brett, who a year later would help to found and act as first chairman of the Ulster Architectural Heritage Society, produced a book on the buildings of Belfast and asked Paddy to take the

pictures. 'Together we spent an enjoyable time travelling round Belfast, often early in the morning when traffic was scarce. At my suggestion Charlie put a stepladder on the roof rack of his car as I had told him it was most helpful, for certain pictures, to be able to stand a few feet above the ground.' This was the cause of a curious incident when the two men went to photograph the façade of Crumlin Road Gaol early one Sunday morning. 'We were on the other side of the road when a senior prison officer came out and wanted to know who we were and what we were doing. Ian Paisley was in the prison at the time. It was particularly awkward for Charlie who had to disclose he was a solicitor!' Three of Paddy's Belfast photographs are included here.

He remembers, 'Another later job was for Mark Girouard who was writing a book on English Victorian pubs. Photographing the amazing interiors of these pubs with their many mirrors was challenging work. And particularly so when, closed and devoid of thirsty clients – and just when one could get down to work – I would invariably be faced with the scene of the staff lying flat out on the floor exhausted.'

After almost a decade of taking pictures, Paddy put away his camera. As he explains, 'I gave up photography in 1972 when I became interested in certain new developments in twentieth-century psychology. The tangible outcome of this was the establishment of Coolmine Therapeutic Community in 1973 at Blanchardstown on the outskirts of Dublin. The project incorporated an entirely new non-medical therapeutic approach for people who were drug dependent.'

Paddy held onto his collection of prints and negatives until 1980 when it passed into the care of the Irish Architectural Archive, established four years earlier. 'I told Desmond FitzGerald that I

would need to sort through everything first as amongst them were photographs of some social occasions, lunch parties with friends not to mention a christening at Bantry House. He told me to leave them in.'

In the field of architectural photography, Paddy Rossmore can be considered something of a pioneer. As already mentioned, before him the late Maurice Craig was almost the only person taking pictures of historic buildings around Ireland, but these shots – some of which were published by the Lilliput Press in 2011 – were primarily for Maurice's own use. Because of his links with the Knight of Glin and the Guinnesses, Paddy's pictures always had another purpose: to educate, to inform, to engage. By the time he stopped taking photographs, the Irish public was better informed about and better engaged with the country's built heritage. In addition, many other people had begun taking photographs of old buildings, as can be seen in the Irish Architectural Archive's rich holdings. Today, with the advent of the smartphone and the opportunities it presents, photography has become an easier and more widespread pursuit, and architecture is a popular subject for these pictures. This was far from being the case when Paddy embarked on his career as a photographer, and his pictures are therefore a marvellous resource for which we should be extremely grateful.

Robert O'Byrne

PHOTOGRAPHS

In the eighteenth century Scottish architect Robert Adam, like a
number of other members of his profession, received commissions
for work in Ireland but never visited the country. One of a
handful of his proposals actually executed was the remodelling
of Castle Upton, an early seventeenth-century plantation castle
originally built for the Norton family. In 1625 it had been sold to
Captain Henry Upton and it was his great-grandson Clotworthy
Upton, first Baron Templetown, who commissioned Adam to
modernize the old castle; unfortunately much of his contribution
was subsequently lost in the nineteenth and twentieth centuries.
However, Adam was also responsible for designing the family
mausoleum in the nearby churchyard. Seemingly dating from 1789,
the building is dedicated to the first Lord Templetown's brother,
the Rt Hon. Arthur Upton, but since he died in 1768 he cannot
have been responsible for commissioning it.

By the time it was erected the estate had been inherited by
the second Lord Templetown, although he would have been a
minor at the time (his father having died in 1785 when the heir
was aged just thirteen). Whatever the explanation, the mausoleum
thereafter housed the remains of successive generations of the
Upton family, although their castle was sold in the early 1960s. Of
limestone ashlar, the mausoleum's front is decorated with classical
urns in niches, swags and recessed discs depicting grieving figures.
Now in the care of the National Trust, the mausoleum is in better
condition than when seen by Paddy.

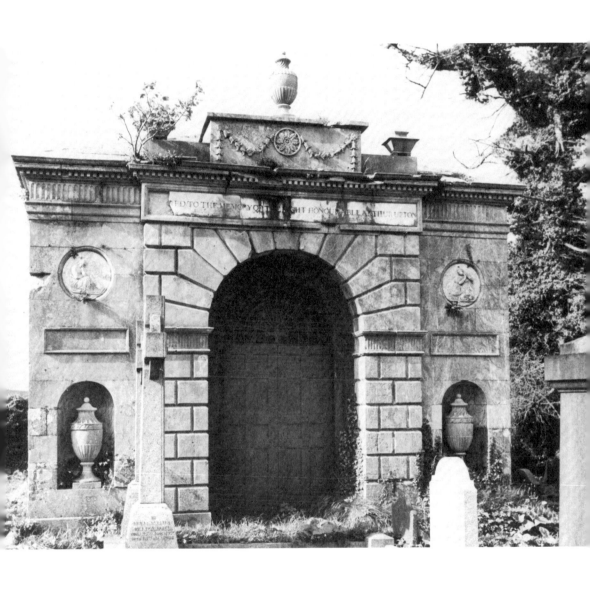

Until the end of the nineteenth century the centre of Belfast's Donegall Square was occupied by the White Linen Hall, a vast late eighteenth-century exchange built around a two-storey quadrangle for trading in what was then the region's most important product. However, in 1888 Belfast was awarded city status and soon afterwards the corporation's members decided that they needed to be housed in more suitable quarters than those they had hitherto occupied. Following a competition, the architect chosen was thirty-year-old Alfred Brumwell Thomas, an advocate of the Baroque revival, of which Belfast City Hall is an excellent example. Following demolition of the White Linen Hall, work began on the site in 1898 and was completed in 1906 at a cost of £369,000, the funds coming from the profits of Belfast Gasworks, for which the corporation was responsible.

Paddy's photograph, taken in the mid-1960s, shows the City Hall from Linenhall Street, its copper dome rising some 173 feet into the sky. Many of the other buildings in the foreground have since disappeared, especially those on the east (right-hand) side since this has been entirely redeveloped in a distinctly characterless fashion.

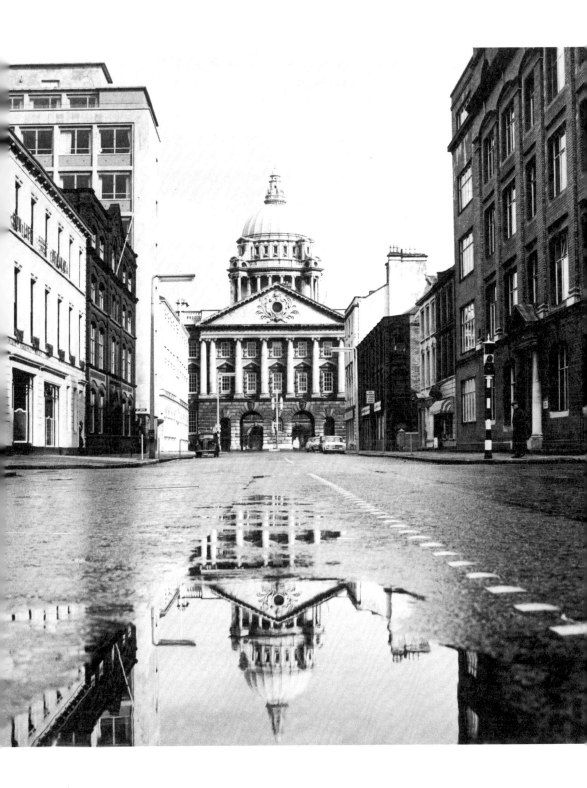

Taken over half a century ago, this is a photograph of a Belfast that has disappeared. It is not just that old women no longer sit on their window ledges smoking pipes (and looking with understandable wariness at a photographer on the opposite side of the street) but that the entire topography of this part of the city is different. This is what much of pre-Troubles Belfast looked like: streets lined with terraces of modest two-storey houses. All have been swept away, replaced by a three-lane highway that sweeps traffic past an area in the process of undergoing redevelopment, with multi-storey blocks of student accommodation on what, in recent decades, had been desolate, vacant lots or surface car parking.

The condition of the houses in Paddy's photograph exhibits their vulnerability: the slipping slates on the roof, the chipped paint on the walls. They were always likely to be demolished. The question is whether what has replaced them can be judged an improvement.

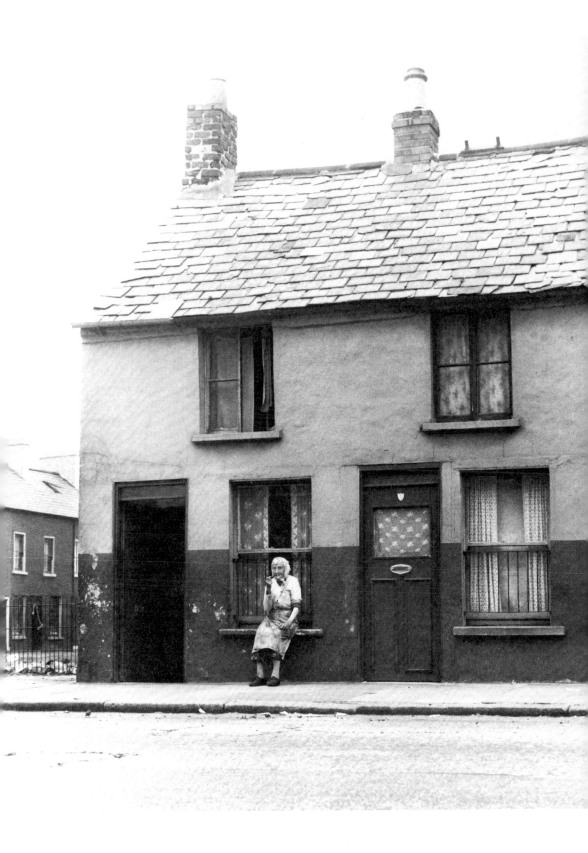

It is ironic that one of the loveliest Roman Catholic churches in Ireland should have been designed by a Quaker. Thomas Jackson was born and raised in Waterford but at the age of twenty-two moved to Ulster and spent the rest of his long life there. He was still relatively young (thirty-three) when he won the competition to design what was intended to be a new Catholic cathedral in Belfast, its foundation stone laid on the feast of St Malachy in November 1841. Cruciform in shape, the building measures 113 by 52 feet and is 40 foot high. This was supposed to be just the sanctuary of the intended cathedral, designed to hold seven-thousand worshippers. However, limited funds, and soon afterwards the onset of the Great Famine, meant work on St Malachy's was concluded in December 1844.

Jackson was a versatile architect, capable of working in whichever style suited his clients. In this instance, he − and they − opted for Tudor Gothic: the church was described by Charles Brett as being 'a superb example of Sir-Walter-Scottery at its most romantic'. The fan-vaulted ceiling is especially fine. Inspired by that of the Henry VII Chapel in Westminster Abbey, it is, according to Brett, 'as though a wedding cake has been turned inside out, so creamy, lacy and frothy is the plasterwork'. St Malachy's merits continue to be appreciated, and in 2008–9 the building benefitted from an extensive restoration programme costing some £3.5 million.

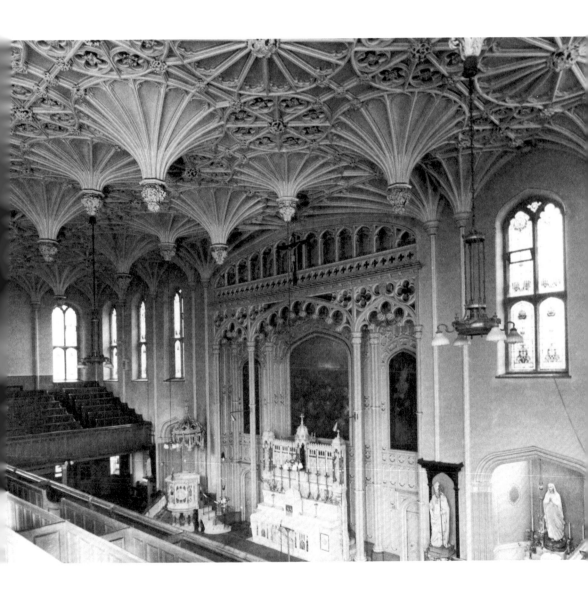

In spring 1961 the Irish Georgian Society's *Bulletin* warned readers
that a house called Browne's Hill in County Carlow was due for
imminent demolition unless a buyer could be found; the house on
just five acres (the Land Commission having taken and distributed
all the rest) was being offered for £2500. Browne's Hill dates from
1763 when built for Robert Browne who the previous year had
married Eleanor Morres and evidently decided he and his bride
required a fitting establishment.

The house, built of local granite, is of six bays and three
storeys over basement, its façade featuring a substantial pedimented
Doric porch not dissimilar to that at Castle Blunden, County
Kilkenny (*q.v.*). The architect is known simply as 'Peters': this may
have been the gardener and landscape architect Matthew Peters
who was then working in Ireland. The superlative entrance gates
of Browne's Hill, for which an unsigned and undated drawing
survives, are attributed to the same person and thought to be of the
same period. Taking the form of a triumphal arch, they feature a
carriage opening flanked by Doric pilasters with Gibbsian postern
gates on either side on each of which sits a lion. A great sweep of
quadrant railings concluded in rusticated piers and signified the
importance of the house beyond. Following intervention by the
Irish Georgian Society, Browne's Hill survived, and was converted
into flats. The magnificent entrance to the estate was acquired by
University College, Dublin, dismantled and re-erected at Lyons,
County Kildare, which was then owned by that institution.

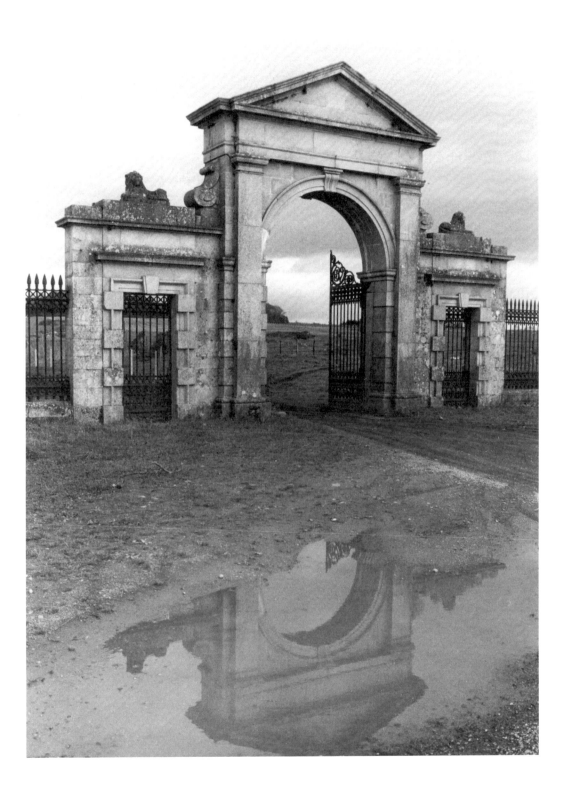

Difficult to imagine now, but buried within Duckett's Grove is an early eighteenth-century house that probably took the form of a regular three-storey over basement, five-bay residence. Not much is known about this building, constructed at some date for a descendant of Thomas Duckett who came from Westmoreland and bought land in this part of the country in 1695. Successive generations of the family had the sense to marry heiresses with the result that they grew ever-more prosperous, with an average annual income of £10,000. This wealth allowed John Dawson Duckett to embark on a gradual transformation of the old house following his marriage to Sarah Summers Hutchinson in 1819.

The architect selected for this task was Thomas Alfred Cobden, believed to have been born in England in 1794, who enjoyed a successful career in Carlow and surrounding counties, designing houses, churches and public buildings in a variety of styles. But nothing matches his work at Duckett's Grove, where the old house was encased in every conceivable Gothic embellishment. This survived into the last century when the house, and what remained of the estate, was sold to a consortium of local farmers. They then fought over the place among themselves, failed to repay a bank loan, the Land Commission assumed responsibility and sold the house and just eleven acres to a businessman in 1931: two years later it was gutted by fire. Duckett's Grove thereafter remained a sad ruin until 2005 when acquired by the local authority that has restored the old walled gardens and secured the building, now a popular weekend destination for people in the area.

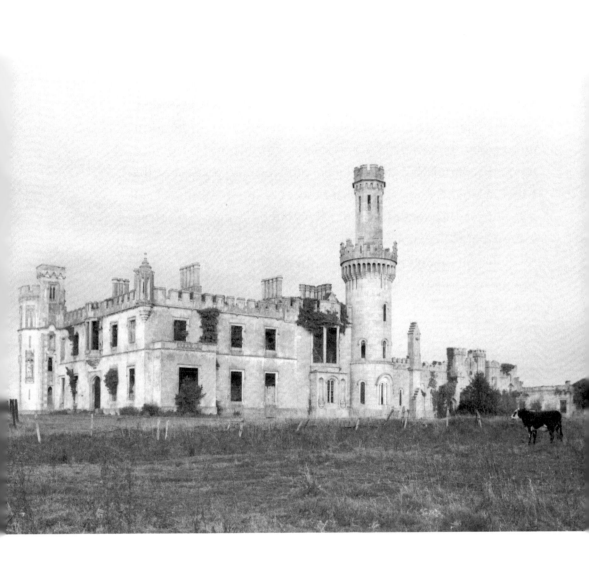

Since being photographed by Paddy, Annaghlee has disappeared, despite being a charming and entirely manageable-sized house. It is thought to have been built *c.*1750, its design tentatively attributed by the Knight of Glin (in the January-March 1964 *Bulletin* of the Irish Georgian Society) to Richard Castle. Like a number of other houses from the same period in this part of the country, red brick was used in the construction.

The photograph shows Annaghlee's entrance front, of two storeys over basement and distinguished by a centre bow on first and second floors, with a single bay on either side. A canted bow to the rear contained the main staircase. Inside, the house was just one room deep, with drawing-room opening to one side of the entrance hall and dining-room to the other, the latter with a service staircase immediately behind. Little seems to be known about its history but within twenty years of Paddy taking this and a number of other pictures, Annaghlee had joined the list of Ireland's lost houses.

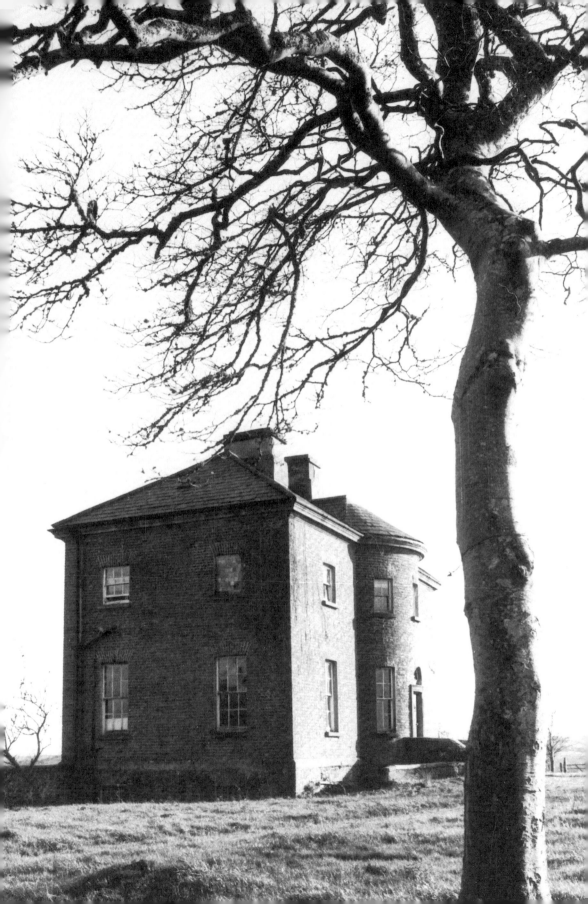

Bellamont Forest has long and rightly been acclaimed as the Palladian villa par excellence in Ireland. One might have expected such a building to be erected close to Dublin or some other large urban centre rather than in the depths of the Ulster countryside, and its presence there is all the more surprising when one realizes that, when first built, this part of Ireland was still unsettled. Occupied by Richard Coote, first Baron Coote of Coloony, there had been a house of some kind in the immediate vicinity but this was evidently unsatisfactory for his younger son Thomas, who *c*.1728 commissioned a new villa from Sir Edward Lovett Pearce to whom he was related by marriage. The result, built on high ground almost entirely surrounded by water, is cubic and of red brick with sandstone dressings, the front marked by an immense pedimented Doric portico of limestone.

The exquisite but compact interior suggests Bellamont Forest was never intended for more than occasional use; somewhere to entertain and to provide a base for hunting and other country pursuits. Paddy's photograph shows the oval lantern lighting the first floor lobby off which open a handful of bedrooms; the ceiling is decorated with delicate rococo plasterwork. At the time of writing, the restoration of Bellamont Forest (having suffered a period of neglect) is nearing completion.

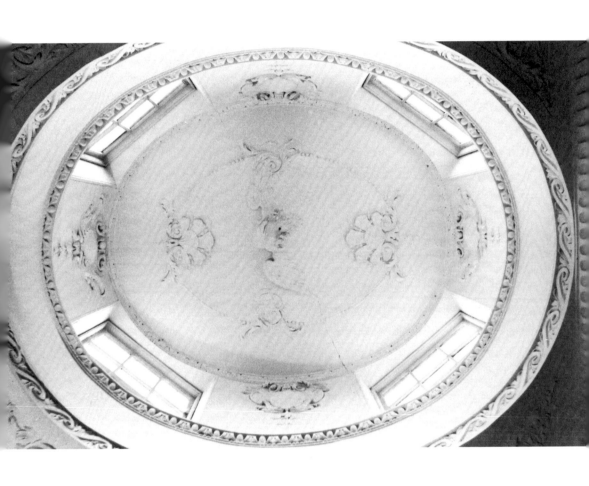

Still occupied by the Ievers family, a great deal is known about the origins of Mount Ievers, since happily the accounts for its construction survive. The house was designed by a local architect John Rothery (with his son Isaac assuming responsibility for the project after Rothery senior's death in 1736) and work began in 1733 with completion four years later. During this time masons working on site were paid five shillings a week, and general labourers five pence. In an average week, eleven of the former and forty-eight of the latter were employed, with the labourers receiving not just their wages but also food and clothes including shoes and supplies of coarse linen woven at Mount Ievers. The house cost £1478 pounds, seven shillings and nine pence to build, but Henry Ievers, who commissioned the building, noted sundry other expenses incurred such as two horses he had given the architect valued at £15, as well as two mules (£4 and twelve shillings) and 3000 laths (£1 and ten shillings). Slates priced at nine shillings six pence per thousand came from Broadford ten miles away, while the oak roof timbers, thirty-four tons in weight, came from Portumna; they were brought by boat to Killaloe and then hauled twenty miles overland to the site.

With a design derived from that of Chevening in Kent (a house attributed to Inigo Jones), Mount Ievers was anachronistic by the time it was built, but one of its many charms are the two identical fronts: that to the north faced in brick, that to the south in cut limestone, both of them of seven bays, three storeys over raised basement and with entrances approached by flights of steps.

Inside, as can be seen here, the north entrance hall, which takes up about a third of the ground floor, includes a wonderful carved staircase, barley-sugar and fluted balusters alternating. This in turn leads to a very substantial first-floor hall off which open the main bedrooms.

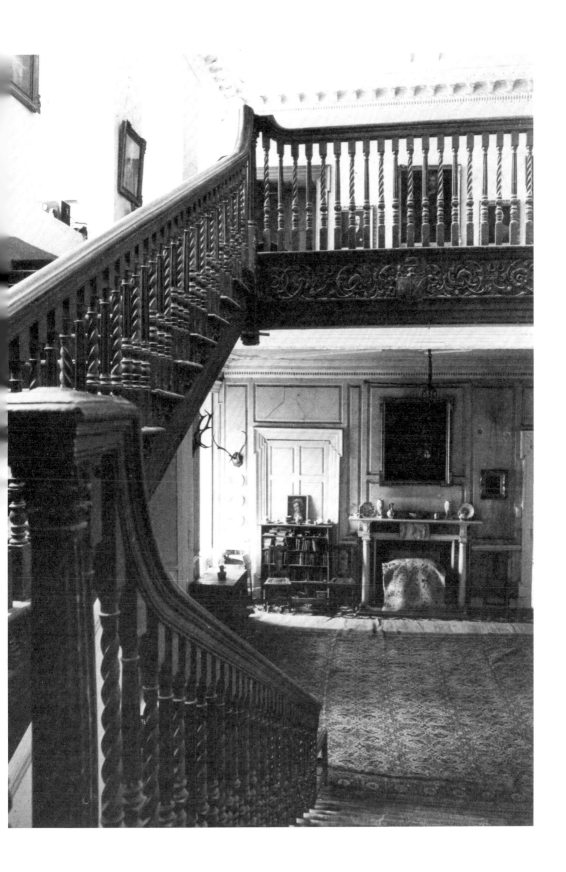

The entrance front of New Hall seen here was added to an older property a few years after the marriage in 1762 of local MP Charles MacDonnell to Catherine O'Brien, third daughter of Sir Edward O'Brien of Dromoland. The groom's family house in Kilkee was destroyed by fire in 1762, which led him to buy the land on which New Hall stands and embark upon a building programme here. His extension is at right angles to the older long house behind, the whole forming a T-shape.

In the April–September 1967 issue of the Irish Georgian Society's *Bulletin*, the Knight of Glin attributed the design of this new section to County Clare gentleman painter and architect Francis Bindon. 'The façade,' he wrote, 'which fronts an older house, is built of beautiful pink brick like Carnelly [another Clare house believed to have been designed by Bindon], but it is composed with a central balustraded and urned octangular bow window incorporating a pedimented front door.'

This attribution has stood for the past half-century, but little work has been undertaken on Bindon in the interim and it is worth noting that New Hall's exterior lacks those features judged most typically Bindon-esque and found in other buildings deemed to be from his hand, such as Woodstock and Bessborough, both in County Kilkenny, and John's Square, Limerick. What might almost be considered the architect's tics, not least the façade having a central curved niche on the first floor and a blind oculus on the second, are not found at New Hall. Instead the house presents such striking elements as raised brick panels, like arched eyebrows, above the first-floor windows, and full-length bows at either end of the structure. Perhaps therefore it might better be described as 'School of Bindon'.

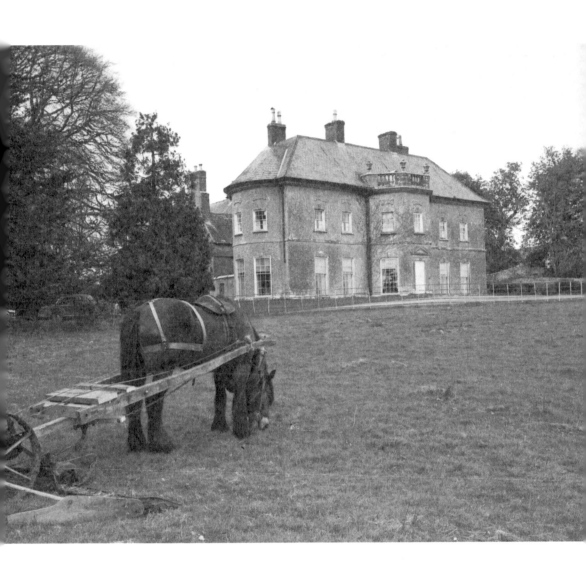

Descendants of MacDonnell remained at New Hall until the early 1920s, after which it was bought by a farming family from neighbouring County Galway: they were in residence when Paddy visited. More recently the property, which was in poor condition, changed hands again, and one must hope the new owner is in a position to ensure New Hall's survival.

The remains of a large castle, originally called Cariganedy, stands perched on cliffs above the Blackwater, its site clearly chosen because it offered an excellent vantage up and down the river. Some old accounts say it was built by the Condons, others that it was built by the Mahonys. Whichever is true, in the second half of the sixteenth century the property passed into the possession of Sir Arthur Hyde, granted some six-thousand acres in this area by Elizabeth I following the attainder of the Earl of Desmond.

The old castle, and its inhabitants, suffered during the Confederate Wars of the 1640s so it is not surprising a new residence was constructed soon afterwards, this in turn replaced by the core of the present building at some date during the second half of the eighteenth century: it has been proposed that the central block was designed by the Sardinian architect-engineer Davis Ducart, who may have been of Italian origin. In 1786 William Wilson's *The Post-Chaise Companion or Travellers Directory Through Ireland* described Castle Hyde as 'a beautiful house, magnificent demesne, highly cultivated, the seat of Arthur Hyde'. Another account of 1825 notes the building as being 'recently greatly enlarged and improved'. This work is likely to have begun at the start of the nineteenth century to the designs of Cork architect Abraham Hargrave; it would appear he was responsible for the additions to the rear and also the wings, giving Castle Hyde's façade a curiously old-fashioned Palladian appearance.

The Hydes remained in occupation until 1851 when their property was offered for sale through the Encumbered Estates Court, this event attributed 'to mismanagement of the estates by agents rather than to any faults on the part of the possessors'. For

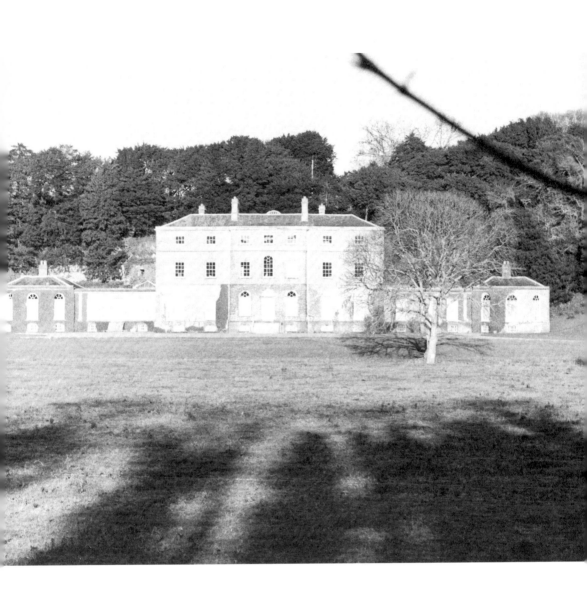

much of the last century the house was owned by Americans before being bought in 1999 by popular entertainer Michael Flatley, who carried out an extensive restoration. At the time of writing, Castle Hyde is once more on the market.

As its name indicates, Castlemartyr was originally a castle, built around 1420 on the site of an earlier fortification on the instructions of James FitzGerald, sixth Earl of Desmond. During the rebellions instigated against the English crown by this family from 1569 onwards, Castlemartyr was occupied by John FitzEdmund FitzGerald but following his capture and subsequent death in 1589, all the land in this part of the country passed into the possession first of Sir Walter Raleigh and then of Richard Boyle, the Great Earl of Cork. He added a domestic range to the old castle, and following damage during the Confederate Wars of the 1640s, this was repaired and made 'English like' by Lord Cork's third son, Roger Boyle, first Earl of Orrery. Further damage was inflicted on the building at the time of the Williamite Wars, after which the castle was left a ruin and a new residence built for the Boyles on a site to the immediate west. This was gradually extended during the eighteenth century, not least by Henry Boyle who, after serving for twenty years as Speaker of the Irish House of Commons, was elevated to the peerage as first Earl of Shannon.

The façade of Castlemartyr is exceptionally long, of seventeen bays and two storeys, and centred on a five-bay recessed entrance with a great pedimented portico. Inside, the house is rather plain except for a superb double-cube saloon added by the second earl soon after his succession to the title. It has a wonderful rococo ceiling in the manner of stuccodore Robert West; Paddy's photograph shows a detail of this work, replete with fanciful birds, flowers and foliage.

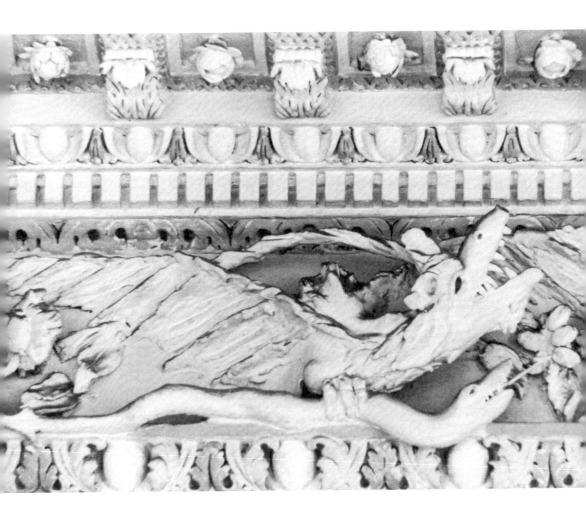

Castlemartyr was sold by the Boyles at the start of the last century, and for many decades was, like so many other country houses, used as an educational establishment by the Catholic Church. More recently it has become an hotel, the saloon converted into a bar.

Built on an island in Cork Harbour, like so many other Irish country houses Fota has experienced a chequered history: its present condition shows no evidence that in the not-too-distant past the building's future existence was imperilled. The house was originally built by a branch of the Barry family as a hunting lodge, and remained as such until inherited by John Smith-Barry, eldest of five illegitimate children of James Smith-Barry, who was only eight when his father died in 1801. It was not until almost a quarter of a century later that he turned his attention to Fota, inviting the architect Richard Morrison and his son William Vitruvius to enlarge and improve the house so that it could become a full-time residence. The Morrisons proposed two schemes, one that transformed the building into a Tudor palace, and the other in strictly classical taste. Smith-Barry opted for the latter, whereby the modest three-storey, five-bay lodge became a substantial house with a seven-bay centre block flanked by single-bay two-storey wings.

Paddy's photograph shows the entrance hall, created by knocking down the walls that once stood on either side and replacing them with screens of paired Ionic columns in yellow scagliola. Above these a frieze features alternate wreaths and the Barry family crest. When Paddy visited, Fota was still occupied by the last of the Smith-Barrys, but in 1975 the house and estate were sold to University College, Cork. There followed alternate periods of restoration and neglect and at times it looked as though the house at Fota was destined to be lost. However, for more than a decade the property has been managed by the Irish Heritage Trust, which has undertaken considerable work not just indoors but in the surrounding walled garden and demesne.

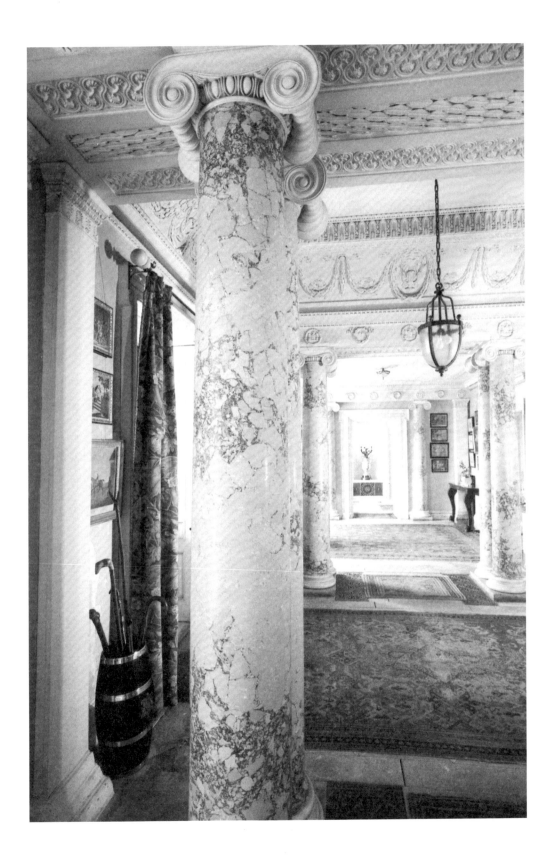

In 2016 the owner of Garrettstown applied for planning permission to reinstate the house as 'a Historic Tourist amenity and living accommodation for the owner's own occupation'. The same application sought to extend the current mobile home and caravan park which now surrounds Garrettstown by the addition of forty-three mobile units. It is all a far cry from what was seen by Samuel Lewis in 1837 when he wrote of the place being 'a handsome house in beautiful grounds, laid out in terraces, gardens and shrubberies, with extensive plantations.' However, it appears Garrettstown has always been somewhat less than what was originally intended, the extant buildings being part of a larger scheme.

Work here was initiated in 1702 by the Kearney family, who levelled a site on high ground to the south-west of Kinsale and with superlative views out to sea. It is believed a splendid Palladian house was planned but only the two wings constructed, one being converted into a residence while the other served as stables. Facing each other across a courtyard, the buildings have identical two-storey façades of mellow local stone, the three centre bays topped by a pediment with limestone Gibbsian doorcases: presumably quadrants would have linked both to the proposed but unconstructed house.

Garrettstown continued to be occupied by the original builders' descendants until sold to the Land Commission in 1950. As can be seen in Paddy's photograph, half a century ago the two main buildings were in a poor state but the stable block has since been restored and is in use as offices for the caravan park. If the intentions expressed in the 2016 planning application are realized, the house, which for decades has stood a shell, will likewise be brought back into usage.

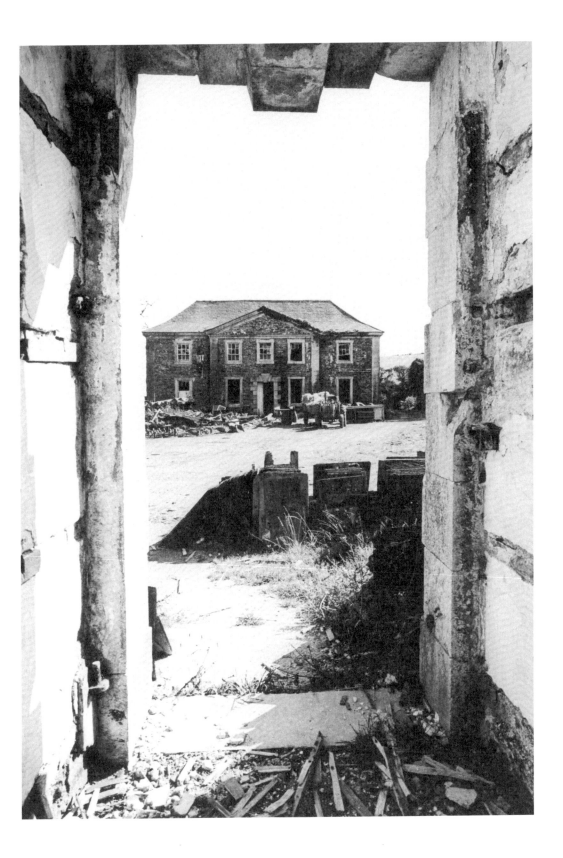

Kanturk Castle is an outstanding example of the fortified houses being built throughout Ireland in the late sixteenth and early seventeenth centuries. However, unlike many of the others it seems not to have been completed or occupied. During the later Middle Ages, the south-west of the country (much of what is now counties Kerry and Cork) was dominated by the MacCarthy Mórs, Kings of Desmond. Following the death of the last of King Donal IX in 1596 leaving only an illegitimate son, a dispute broke out between various members of the family over who was entitled to claim his position.

One of the contenders was Dermot MacOwen MacCarthy, simultaneously in dispute with a cousin, Donogh MacCormac MacCarthy, for the title of Lord of Duhallow (one of the three subordinate septs of Desmond). Yet in 1598 the two men joined forces to attack Castle Hyde (q.v.), home of the settler Arthur Hyde, which after a three-day siege was captured and burnt. They then reverted to their earlier quarrel over the Lordship of Duhallow which, following the death of Donogh during a skirmish in the Clare-Galway region in 1601, Dermot secured for himself. Soon afterwards he began work on the construction of a new residence in Kanturk, a popular legend being that it was built by seven stone-masons each named John (for a time the building was known as 'Carrig-na-Shane-Saor': the Rock of John the Mason).

Work on the site seems to have stopped in 1618 after English settlers in the area objected to the castle being too large and too fortified. Kanturk Castle later passed into the hands of one of those settler families, the Percevals; in 1900 the widow of a descendant presented it to England's National Trust. More recently it in turn

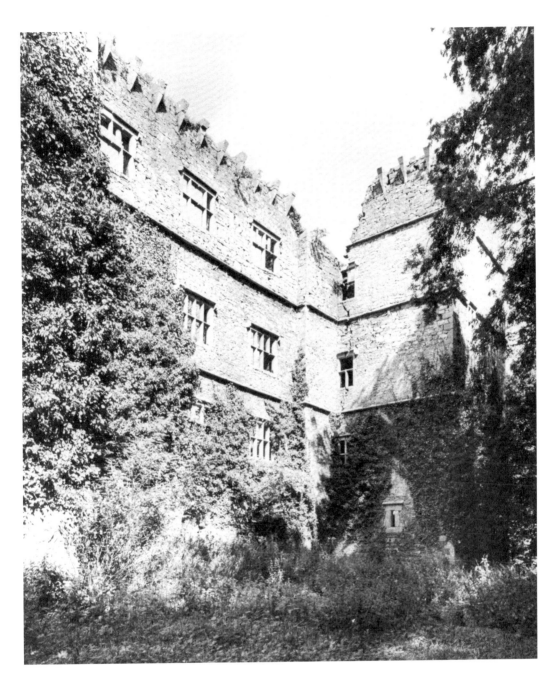

passed on the title deeds to An Taisce (a long-established charitable organization engaged in the preservation and protection of Ireland's natural and built heritage) and is cared for by the Office of Public Works. Paddy's photograph shows the building before more recent conservation work had taken place.

Like Castletown Cox, County Kilkenny (*q.v.*), Kilshannig was designed by the somewhat shadowy engineer and architect Davis Ducart. The house was built in the mid-1760s for a rich Cork burgher and banker, Abraham Devonsher who, having been elected as Member of Parliament for the local pocket borough of Rathcormack, evidently decided he should have a seat in the area. On rising ground and facing south, Kilshannig conforms to the Palladian manner, the central block flanked by courtyard wings on either side. The façade is fronted in lovely mellow brick except for the three-bay entrance, reached via a flight of sandstone steps.

Charming though its exterior may be, the real delight lies inside where the main reception rooms feature some of the finest surviving plasterwork by Ticinese-born stuccodore Filippo Lafranchini. The entrance hall has a coved and sectioned ceiling filled with an abundance of swags and foliage and baskets of fruit. It provides access to the central reception room, a saloon that is half as high again as the entrance hall, and has a ceiling centred on three exquisitely worked figures of Bacchus, Ariadne and Pan. Around them double medallions contain the four elements, as well as Justice and Minerva. To the left lies the dining-room the ceiling of which, like that in the entrance hall, is predominantly given over to foliage and fruit but also contains clusters of dead game and masks. At the other end of the saloon, the library has a ceiling with a central frame containing the figures of Apollo and Diana, as well as corner sections featuring the Four Seasons, and immediately above the cornice framed female heads in profile are believed to represent members of the Devonsher family.

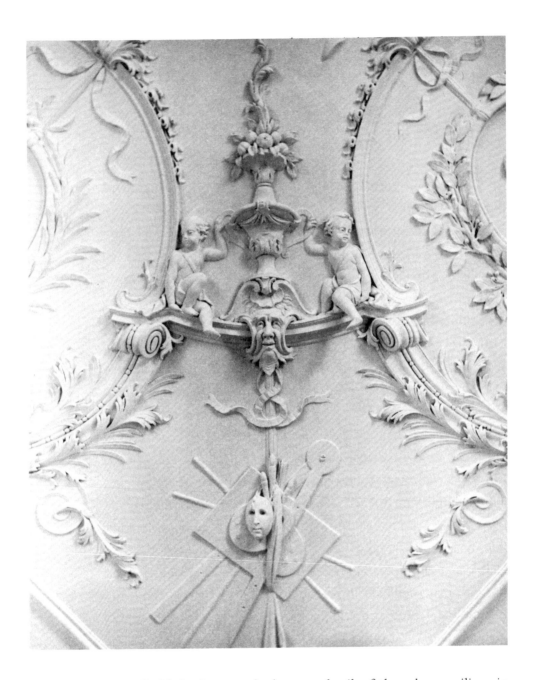

Paddy's photograph shows a detail of the saloon ceiling, in which a pair of putti rest above various items representing the art of painting. In the nineteeth century Kilshannig was bought by the Roches, Barons Fermoy. They in turn sold it and the property passed through various hands before being acquired by the present owner's family, who have done much in recent years to restore the house.

In 2008 Vernon Mount was placed on the World Monuments Fund List of 100 Most Endangered Sites. Eight years later it was destroyed by arsonists. Paddy's photograph shows what was then lost: a remarkable interior that included this first-floor landing, an oval space around which ran eight marbleized Corinthian columns interspersed with seven doors painted with tromp l'oeil niches 'containing' classical statues and urns. The artist responsible was Nathaniel Grogan the elder (1740–1807) who spent a number of years working in North America before returning to his native Cork. The American link is significant, because as its name indicates, Vernon Mount was built in homage to George Washington and his own country residence in Virginia, Mount Vernon.

Located to the south of Cork city on raised ground with panoramic views over the River Lee valley, Vernon Mount was highly unusual in design, a two-storey over basement villa, the curved entrance front having symmetrical convex bows on either side; its architect is thought to have been a local man, Abraham Hargrave. It had been commissioned by Sir Henry Browne Hayes, who in 1801 would be brought to trial in Cork for abducting Quaker heiress Mary Pike four years earlier and forcing her to participate in a spurious marriage. Found guilty, he was sent to Australia, but only spent a few years there before returning home (poor Miss Pike, meanwhile, lost her wits as a result of the abduction and spent her final years in a lunatic asylum).

In the middle of the last century Vernon Mount and its surrounding land was purchased by the Cork and Munster Motorcycle Club, which developed a motor race track on the site but maintained the building. However, in the 1990s the place was

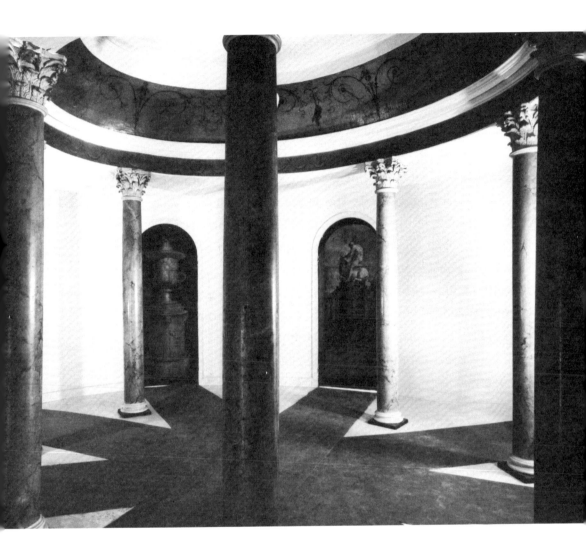

sold to a consortium of developers, which, thwarted by its attempts to build a hotel complex, left Vernon Mount to fall into ruin. Despite valiant efforts to ensure the building's survival, not least by a group of concerned locals, following decades of neglect the house was gutted by fire in July 2016, a reflection of Ireland's lax attitude towards preservation of the national architectural heritage.

In April 2014 it was announced that the Drenagh estate, which had been in the hands of the McCausland family since the early eighteenth century, was to be sold for a sum in the region of £10 million. Originally from Scotland, the McCauslands had settled in this part of the country during the reign of James I, and in 1729 Robert McCausland, who had acted as agent for William Conolly, Speaker of the Irish House of Commons, inherited from the latter the land on which Drenagh now sits: this explains why generations of male McCauslands have been given the first name Conolly. The present house is of a later date, replacing an earlier building elsewhere on the estate. It was commissioned in 1836 by Robert McCausland's great-grandson Marcus, the first private client of architect Charles Lanyon, then aged just twenty-three and only beginning what would prove to be a highly successful career.

Given Lanyon's youth, Drenagh is an astonishingly confident piece of work, albeit one that takes risks. Clad in pink-hued sandstone ashlar, the two-storey façade has an Ionic portico and a two-bay pedimented breakfront on another side but otherwise the exterior is plain. Internally the dominant space is the top-lit inner hall with screens of fluted Corinthian columns leading to a double-staircase with cast-iron balusters. It is this view that Paddy has captured, the upper landing and rich vaulted ceiling plasterwork reflected in one of the convex mirrors on the ground floor. Drenagh happily remains in the ownership of the McCauslands, their financial difficulties resolved by the sale of some of the land. The house is now used as a wedding venue.

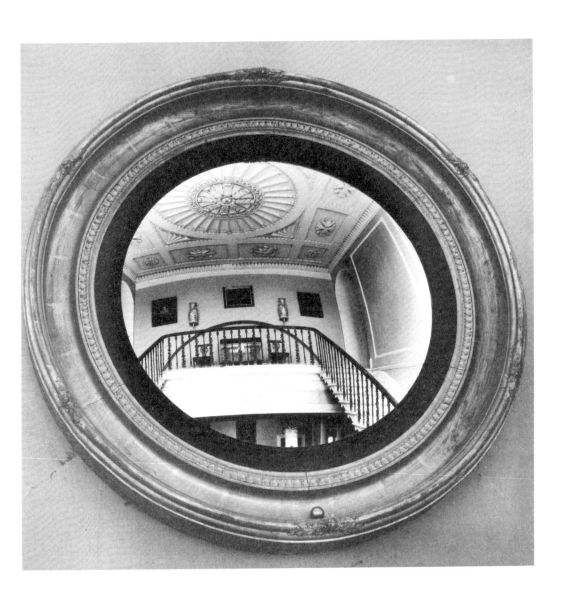

When Paddy photographed Prehen, the house was in perilous condition. A few years later it was restored but the future of the building is once again unsure. Overlooking the River Foyle and on the outskirts of Derry city, the house was built by Andrew Knox, long-time MP for Donegal in the Irish Houses of Parliament, some years after his marriage in 1738 to heiress Honoria Tomkins. Its design is attributed to Michael Priestley, about whom relatively little is known except that he was responsible for a number of buildings in north-west Ulster. Of rubble with ashlar dressings, the house is of two storeys over basement and has four bays, the centre two being slightly advanced and featuring a substantial sandstone Gibbsian doorcase: the interior is equally fine, beginning with a flagged entrance hall off which open a series of reception rooms to left and right while symmetrical doors to the rear give access to a main and service stairs respectively. A similar arrangement pertains on the first floor where the central space to the front of the building is taken up by an impressive gallery with coved ceiling.

The Knox family remained at Prehen until the outbreak of the First World War when, the heir to the property being a German baron, it was seized by the British government as enemy property. It served as troop accommodation during the Second World War and then passed through various hands. By the 1960s the building had been divided internally, with Paddy's photograph showing how a secondary door had been inserted into one of the main entrance's sidelights. On the verge of complete dereliction fortunately Prehen was bought by Julian Peck and his American-born wife Carola: the couple had previously restored Rathbeale, County Dublin. Peck had a family link with the place, his mother

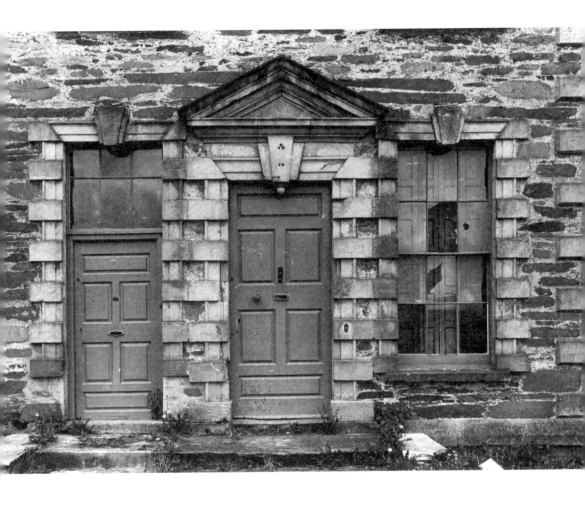

being author Winifred Peck (*née* Knox), one of a remarkable band
of siblings whose other members included Monsignor Ronald
Knox, Roman Catholic priest and detective-story writer, and
Alfred 'Dilly' Knox, who worked as a code breaker during both the
First and Second World Wars. The Pecks rescued Prehen, bringing
the house back to life. Unfortunately, since their deaths and those
of their sons, the building stands once more silent and vulnerable.

Now in the centre of the county town, Donegal Castle stands in what for many centuries was territory controlled by the O'Donnells, hence the building's alternative name of O'Donnell's Castle. It was built towards the end of the fifteenth century and was so substantial that in 1566 then-Lord Deputy of Ireland Sir Henry Sidney described it as 'the largest and strongest fortress in all Ireland,' before noting, 'it is the greatest I ever saw in an Irishman's hands: and would appear to be in good keeping.'

The O'Donnells remained in possession of the castle until the early seventeenth century, when it was granted along with a thousand acres to Basil Brooke, an English soldier who had come to Ireland during the Nine Years War. Knighted in 1616, Brooke set about restoring the castle, which had been left in a ruinous state, adding large new windows to bring light into the old keep and adding a wing so that it was transformed into a Jacobean manor house.

When Sir Basil's descendants moved to County Fermanagh in the 1670s, they sold Donegal Castle to the Gores, future Earls of Arran. Although the building survived the Williamite Wars relatively unscathed, it gradually fell into disrepair and eventual ruin. In 1898 the fifth earl transferred responsibility for the castle to the Office of Public Works. Almost a hundred years later, that body undertook restoration work on the building, re-roofing the old castle and installing floors and doors, although the later section remains a shell. This photograph shows one of the chimneypieces installed during the tenure of Sir Basil Brooke and featuring his coat of arms.

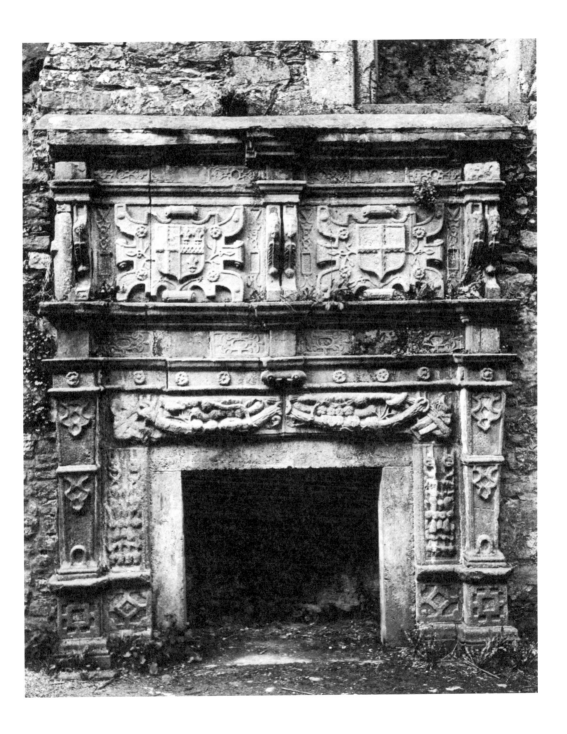

Professor Alistair Rowan once observed that Ballywalter Park possesses 'a metropolitan air and all the architectural trappings of a London club, dropped as if by chance in the open country of the north Irish coast'. Indeed the building might have been designed for Pall Mall by Sir Charles Barry, but instead was designed for County Down by Sir Charles Lanyon. There was an earlier house called Ballymagown on the site, but this was encased in a much larger structure after the property had been acquired in 1846 by Andrew Mulholland. He was a prominent member of what became known as the Linenocracy, a group of predominantly Ulster families who became exceedingly rich thanks to their involvement in the region's linen industry. By the time Mulholland showed William Thackeray around one of his mills in Belfast in the early 1840s, he was employing some 500 persons on this premises alone; by the mid-1850s, the York Street flax mill was probably the largest such enterprise in the world. Mulholland's wealth allowed him to become a country gentleman, as did his son John who in 1892 was created first Baron Dunleath.

Ballywalter Park was built to reflect the gentlemanly tastes of the time, the interior containing such essential spaces as a mahogany-lined library, morning-room, drawing-room and dining-room. All of these are accessed from the house's finest feature, the inner hall which features in Paddy's photograph. Around the first floor of this double-height room runs a gallery above which is the glazed roof filling the space with natural light: note how plain Doric columns and pilasters of the ground floor give way to the richer Corinthian order on the gallery so as to encourage the eye upwards. Both opulent and comfortable,

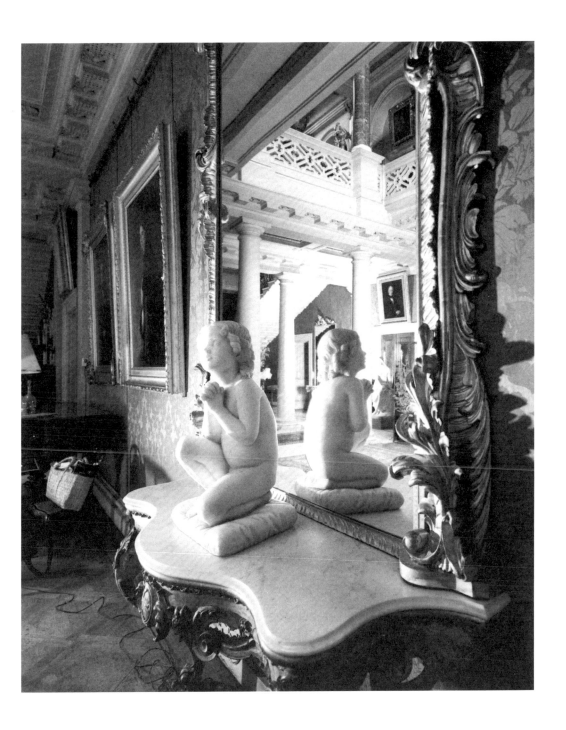

Ballywalter Park remains very much a treasured family home, and has benefitted from sensitive refurbishment undertaken by the present Lord Dunleath and his wife.

There is a link between Castleward and Gill Hall (*q.v.*) since prior to her marriage to Bernard Ward, Lady Anne Bligh, daughter of the first Earl of Darnley, had been the wife of Robert Hawkins-Magill of Gill Hall: their only child, Theodosia Hawkins-Magill in turn married John Meade, future first Earl of Clanwilliam. Long before then, of course, Lady Anne – who had been widowed in 1745 after just three years of marriage, had become the wife of Mr Ward and with him embarked on building a new house overlooking Strangford Lough. Famously the couple could not agree on what style they wanted for the building. Mr Ward (who created Baron Bangor in 1770, and then Viscount Bangor in 1781) preferred the classical style, whereas his wife fancied Gothick. As Mrs Delany wrote around this time:

> Mr Ward is building a fine house, but the scene about is so uncommonly fine it is a pity it should not be judiciously laid out. He wants taste, and Lady Anne is so whimsical that I doubt her judgment. If they do not do too much they can't spoil the place, for it hath every advantage from nature that can be desired.

Ultimately a compromise was reached whereby Mr Ward had his way on the entrance front, and Lady Anne hers on the side overlooking the water. Internally the same division was agreed so that the ground floor rooms are quaintly split between the two decorative styles. The architect responsible for organizing this curious arrangement is unknown, although it has been proposed that, like the stone used for the exterior, he came from Bath or else Bristol (the names of both James Bridges and Thomas Paty have been mentioned).

Nevertheless the arrangement was not enough to hold the Ward marriage together and soon after Castle Ward was finished, Lady Anne, who complained of being bullied, decamped first to Dublin and later to Bath where she died in 1789, eight years after her husband. Paddy's photograph shows a detail of plasterwork by an unknown hand that covers the walls in the classical former entrance hall.

When Paddy visited Gill Hall, it was already in an advanced state of decay and just a few years later, in June 1969, the house was left a shell after being gutted by fire. The loss to Irish architectural heritage was considerable, since Gill Hall was an important early house. Taking its name from Scotsman Captain John Magill who settled here in the mid-seventeenth century, the building dated from 1670–80 and was therefore one of the country's earliest unfortified domestic structures. The three-storey Gill Hall was enlarged c.1731 by Robert Hawkins-Magill with shallow bow-fronted wings added on either side of the front, thought to have been designed by Richard Castle. Approached by a short flight of steps, the doorcase, seen here, was particularly fine, with dophins carved in the spandrels beneath a segmental arch framed by Doric columns. The interior was notable for retaining its seventeenth-century panelling and a staircase with barley-sugar banisters and carved swags of foliage.

The setting of the famous Beresford Ghost Story, Gill Hall was reputedly the most haunted house in Ireland. When the fifth Earl of Clanwilliam, whose forebear had married the Hawkins-Magill heiress in 1765, brought his own young wife to Gill Hall in 1909 she refused to live there and so for long periods it sat empty, although used by the RAF during the Second World War. In 1966 an architect wrote that for many years 'the ceilings and roof timber have been exposed to wind and rain, loose slates have been lifted and the heart of the building was laid open'. Although the Irish Georgian Society carried out some emergency repairs, it was not sufficient to save Gill Hall, and after the fire of 1969 the remains were demolished.

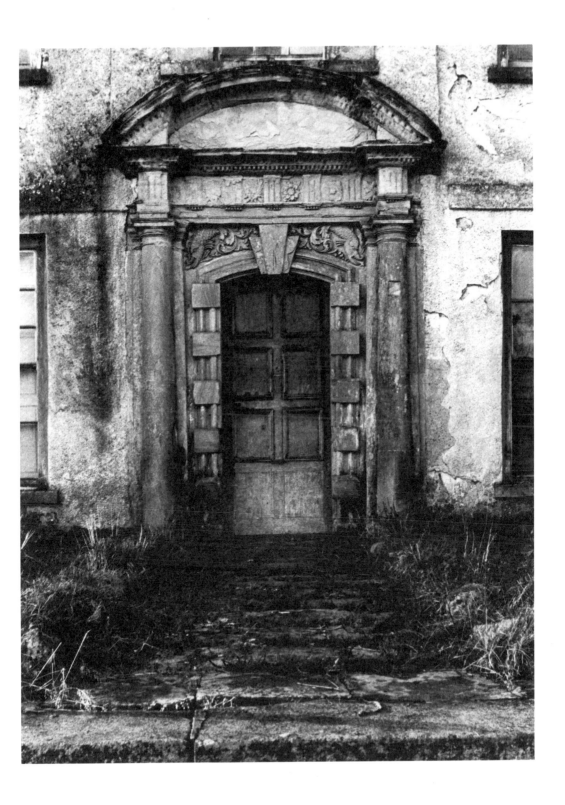

The sensational gardens of Mount Stewart enjoy global renown, but the interior of the house at their centre is less well-known, despite containing many remarkable rooms, not least the octagonal inner hall seen in Paddy's picture. The land on which it stands was bought in 1744 by the trustees of heiress Mary Cowan who seven years earlier had married her cousin, a successful merchant called Alexander Stewart. The house already standing here was then called Mount Pleasant; now it was changed to Mount Stewart. The building underwent a series of transformations, some of the most significant initiated by Alexander and Mary Stewart's eldest son Robert who gradually climbed the peerage until created first Marquess of Londonderry in 1816. It was Robert Stewart who commissioned a new west front to the house, designed in the first years of the nineteenth century by London-based architect George Dance the younger. However, the most substantial additions to Mount Stewart were made several decades later when the third marquess employed William Vitruvius Morrison. The octagonal hall is one of the latter's designs, a top-lit space with a balustraded gallery around the first-floor supported by paired Ionic columns.

Originally furnished with cabinets containing a Chinese export armorial service, the hall was filled by the fourth marquess with over three-thousand antlers, mounted animal heads and suits of armour. It later became a sculpture gallery with work such as this life-size figure of Venus. The black-and-white check floor laid in the 1960s has recently been removed, replaced by a former monochrome sandstone. Since 1977 Mount Stewart has been under the care of the National Trust.

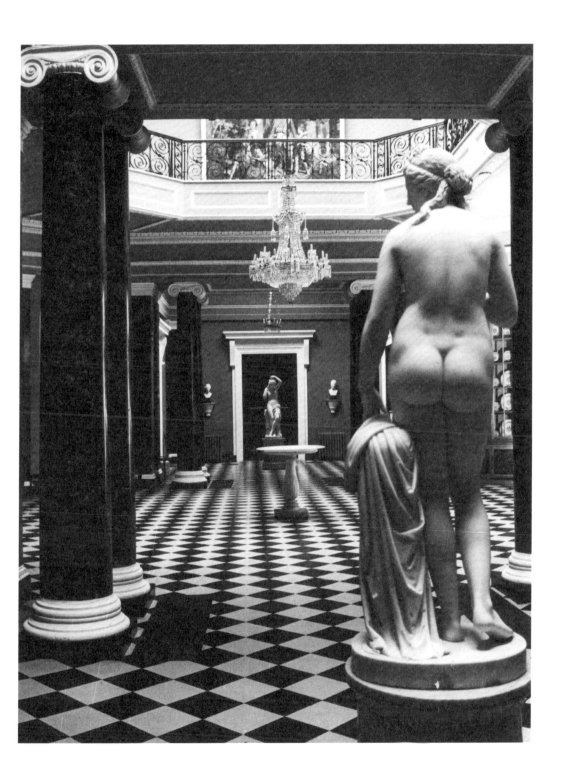

The eighteenth-century English polymath Thomas Wright (1711–86) is usually described as being an astronomer, mathematician, instrument maker, archaeologist, historian, pedagogue, architect and garden designer. He was also evidently a man of great charm since he never wanted for friends or patrons and despite modest origins moved with ease from one country house to the next. In many respects, he can be considered the successor of William Kent who likewise rose from humble beginnings to enjoy a stellar career across a diverse range of disciplines. But whereas Kent never came to Ireland Wright did so, spending a year in this country in 1746–7. During this period he undertook the necessary research and made drawings for a book published in London in 1748, *Louthiana*. As its name indicates, the subject was County Louth and the work is the first example of such a survey of archaeological remains in Britain or Ireland.

Wright came to Ireland at the invitation of his friend James Hamilton, first Viscount Limerick (and later first Earl of Clanbrassill). Although his main residence was on the outskirts of Dundalk, he also owned an estate farther north at Tollymore, County Down, and in September 1746 he and Wright travelled there for a stay of eight days. Subsequently a number of Gothick structures were erected in the demesne. If not designed by Wright, these certainly demonstrate his influence. Indeed the influence lingered on long after both polymath and patron had died: Tollymore's fanciful Barbican Gate, seen here, was built by the second Earl of Clanbrassill in 1780 as the main entrance to the estate. In the last century Tollymore was bought by the Northern Ireland Ministry of Agriculture and is today a public forest park.

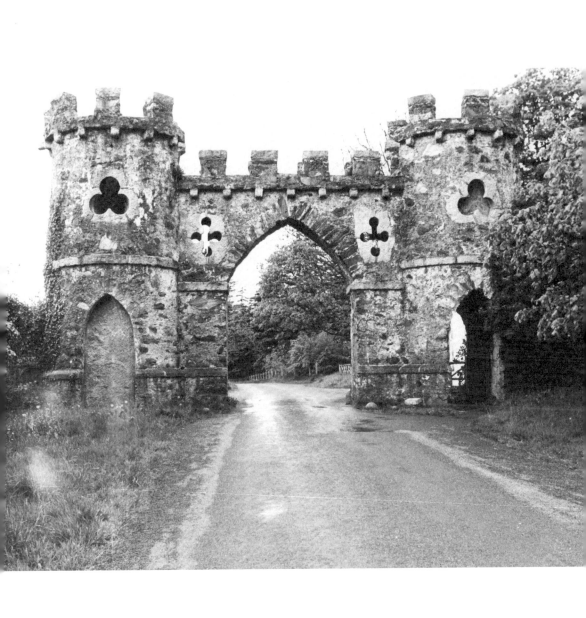

Paddy's photograph captures Quintin Castle at its most dramatic, perched above the rocks on the eastern side of the Ards Peninsula. The building has had a complicated history, changing hands many times. The original castle is said to have been built by the Anglo-Norman knight John de Courcy who arrived in Ireland in 1176. It subsequently passed into the ownership of the Savage family, whose forbear had arrived with de Courcy, and then to that of their dependents, the Smiths. In the middle of the seventeenth century, Sir James Montgomery who lived on the other side of the peninsula at Rosemount, purchased the castle and surrounding land, and carried out many improvements, adding an enclosed courtyard to the front of the building. In turn the Montgomerys sold Quintin Castle to another local landowner, George Ross, but while his descendants retained ownership, they did not occupy the property. It was only in the nineteenth century, following the marriage of Elizabeth Ross to the Rev. Nicholson Calvert, that the castle was renovated and once more used as a residence. (Calvert's mother was the Hon. Frances Pery, from whose fascinating journals extracts were published in 1911 as *An Irish Beauty of the Regency*.) It has been proposed that the architect William Vitruvius Morrison was employed here prior to his death in 1838; if so, he was responsible for raising the height of the central tower, as well as adding drawing- and dining-rooms.

During the last century, Quintin Castle once more had several owners, one of whom used the building as a nursing home. In 2006 it was sold again but the purchaser experienced financial difficulties and in 2013 Quintin Castle was on the market once more. Its latest owners have sought planning approval for the building to be used as a venue for weddings and other functions.

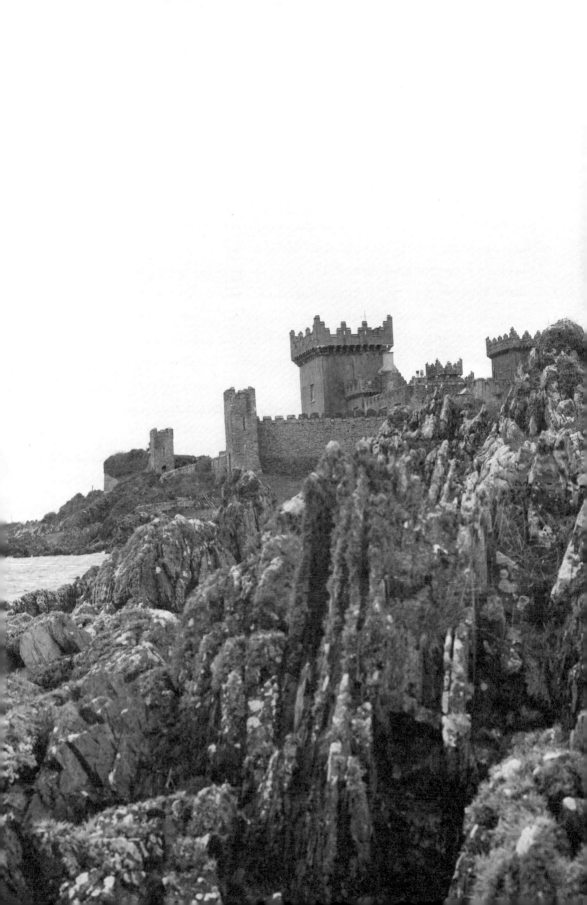

STAIRCASE HALL, KENURE PARK,
COUNTY DUBLIN

An immense stone Corinthian portico rising above local authority
housing is all that remains today of Kenure Park. The lands in
this part of the country north of Dublin came into the possession
of the Butler family in the early fourteenth century, but the first
house on the site was only built some four hundred years later by
James Butler, second Duke of Ormonde. After the failed Jacobite
Rising of 1715 and his voluntary exile to France, the duke's lands
were forfeited and subsequently purchased by Henry Echlin,
a lawyer who was created a baronet in 1721. In the second half
of the eighteenth century, Kenure came into the possession of
his granddaughter Elizabeth, who had married Francis Palmer,
originally from County Mayo. It was the third Palmer baronet,
Sir William, who owned Kenure in 1827 when the old house
was severely damaged by fire, and who some fifteen years later
commissioned architect George Papworth to refurbish the building.
Among his additions were the aforementioned stone entrance
portico and the immense central staircase hall shown in Paddy's
photograph. Top-lit by windows containing armorial stained glass,
the lower section featured walls of yellow scagliola with Doric
columns while the upper portion's walls had grey marbled Ionic
pilasters; through all this rose an imperial staircase with elaborate
scrolled iron balustrades.

 The last of the Palmer family to own the house sold the
contents in a four-day sale in September 1964 after which Kenure,
acquired by the local authority, sat empty and a prey to vandals
until demolished – other than the portico – in 1978. Pictures such
as this one gives an idea of what was lost.

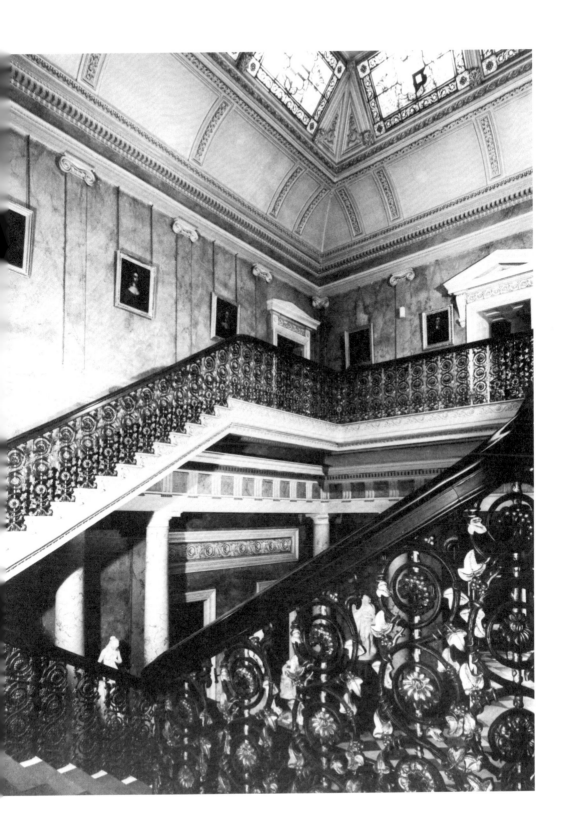

In their book on early Irish gardens (*Lost Demesnes: Irish Landscape Gardening 1660–1845*, 1976) Edward Malins and the Knight of Glin described the Rustic Arch at Luttrellstown as 'perhaps the finest of its kind in Ireland, the tufa dripping with ivy and ferns'. Believed to date from *c*.1765, the arch is but one feature in the demesne of Luttrellstown which in its present form dates from the second half of the eighteenth century, thanks to Simon Luttrell, first Earl of Carhampton and his son Henry, second earl. They transformed what had been a formal garden into a naturalistic landscape replete with woodland, stretches of water and romantic meandering pathways. Luttrellstown soon became renowned for the beauty of its grounds, the German Prince Pückler-Muskau declaring in the mid-1820s that 'scenery, by nature most beautiful, is improved by art to the highest degree of its capacity, and, without destroying its free and wild character, a variety and richness of vegetation is produced which enchants the eye'.

 The Rustic Arch was a key element of the demesne. It carries over a ravine and features a hermitage that originally contained three rooms intended for entertaining (alterations were made to the interior in 1999 for a celebrity wedding). The exterior is given the form of a faux-ruin, the walls made of rough-hewn rocks through which are pierced arched Gothic windows; these once contained glass, now long-since lost. The Rustic Arch itself risks a similar fate, since it has suffered dangerous neglect in recent years with sections of the stonework collapsed: in 2017 An Taisce added the structure to its list of buildings at risk.

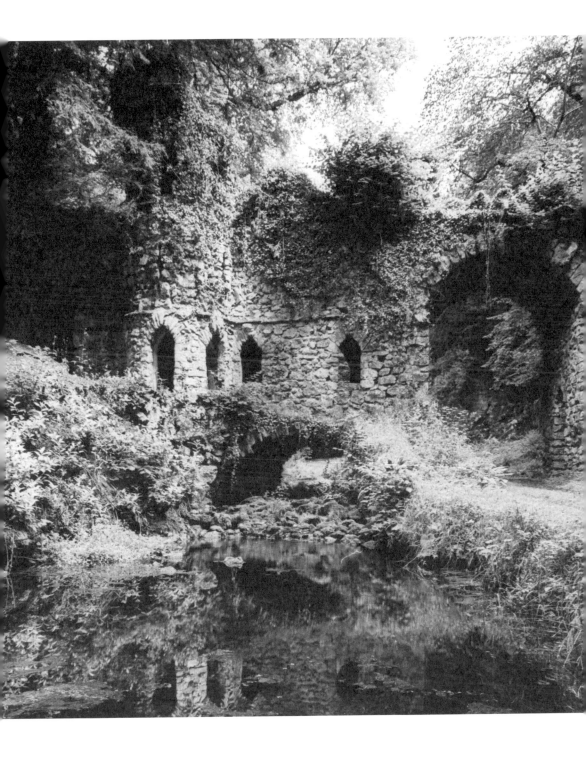

Paddy's photograph shows the façade of Seafield, from which are wonderful views looking across an estuary towards Malahide. Dating from *c.*1730, the house is defined by its masterful two-storey granite pedimented Doric portico approached by a flight of steps. Sir Edward Lovett Pearce has sometimes been claimed as the architect and while the late Maurice Craig argued that a 'slight awkwardness in the handling' of certain elements discouraged this attribution, 'it is, even so, certain that Seafield is a building of the Pearce school, and even possible that the design was outlined by him and executed by someone else.' Internally, an immediate impression is made by a single feature: the double-height entrance hall that runs the full depth of the building, its walls lined with superimposed fluted Ionic and Doric pilasters, the spaces between them filled with grisaille classical figures. The space looks much as it did when photographed by the first Irish Georgian Society for the fifth volume of its *Records of Eighteenth-Century Architecture and Decoration in Dublin*, published in 1913.

Seafield was originally owned by Benedict Arthur, whose descendants appear to have remained there for much of the eighteenth century. In 1834 it formed part of the inheritance of Sophia Synge-Hutchinson, daughter of the Rev. Sir Samuel Synge-Hutchinson who that year married her cousin, the Hon. Coote Hely-Hutchinson, and members of their family were responsible for adding a large extension to the east side of the house that can be seen in Paddy's photograph. Happily, Seafield has been well maintained by successive owners to the present day.

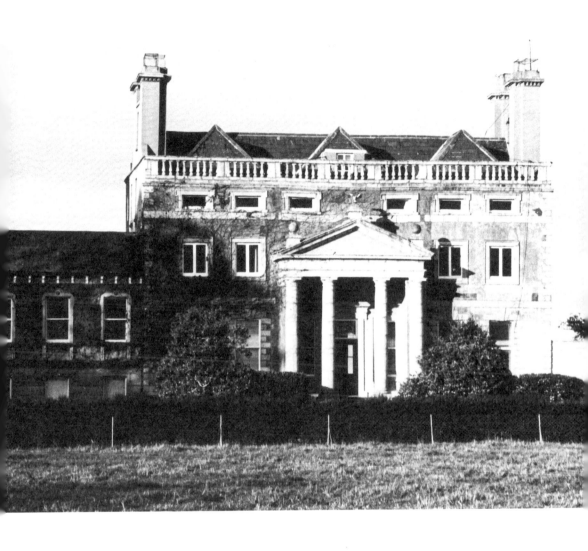

The demolition of Turvey in 1987 took place under such questionable circumstances that just over a decade later it was discussed at the Flood (later Mahon) Tribunal established to investigate corruption in planning decisions and land rezoning. Turvey was without doubt one of the most important and most ancient houses in County Dublin, with a history dating back to the mid-sixteenth century when built by Sir Patrick Barnewall, seemingly using stone from a former convent in the area. The building subsequently underwent modifications and expansion in the seventeenth and eighteenth centuries while the Barnewalls were created Viscounts Barnewall of Kingsland. Following the death in a French lunatic asylum of the childless fifth viscount in 1800, the title was claimed by Matthew Barnewall, a Dublin barrow boy who, rather like the fictional Tess Durbeyfield, believed himself to come from noble stock. With a group of supporters he occupied Turvey and embarked on a legal battle to retain his supposed inheritance: opposing him was Nicholas Barnewall, fourteenth Baron Trimlestown. In 1814 the House of Lords finally confirmed Matthew Barnewall's right to the viscountcy but this did not come with any property, and he would die penniless in London twenty years later. Turvey passed to the Trimlestowns and remained with them until 1918 when financially obliged to sell the place: its next owners likewise suffered from penury and had to dispose of the property half a century later.

Paddy's photograph captures the house shortly before this event, and shows it still in good condition. Over the next twenty years Turvey was allowed to fall into ruin. Even so, it is astonishing that prior to the building's demolition the local authority's senior architect could declare the place to have 'no great architectural merit apart from its antiquity'. A great loss.

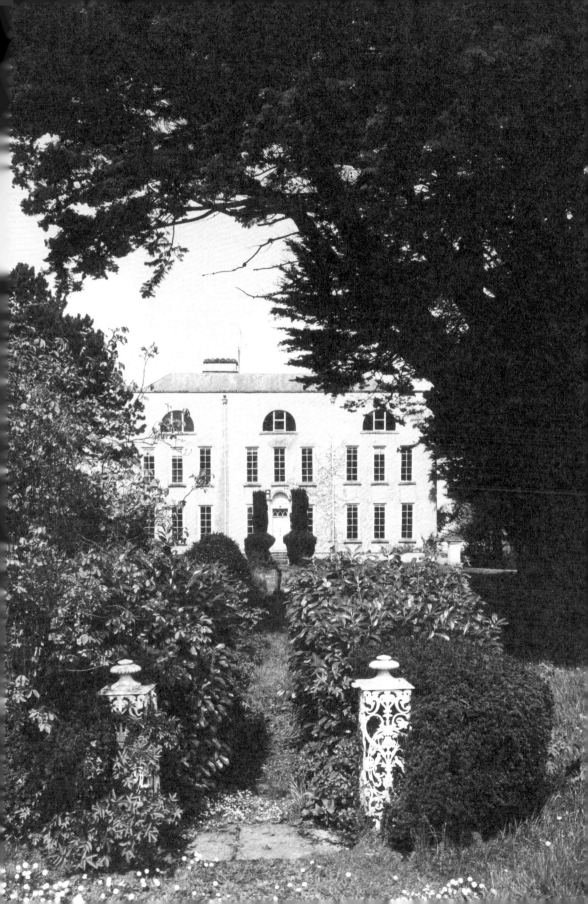

Lisreaghan was formerly an estate owned by the Lawrence family,
which had originally settled in the late sixteenth century nearby
at Ballymore Castle but, having espoused the Royalist cause, were
dispossessed of this during the Cromwellian period. In 1730 the
Lisreaghan estate was inherited by one-year-old Walter Lawrence
following the deaths of both his parents. On reaching adulthood
and following the requisite Grand Tour of mainland Europe, he
built a large new residence for himself, called Bellevue or Belview.
In 1782 Lawrence further commissioned a new entrance to his
estate, a monumental gateway intended to commemorate Henry
Grattan's efforts to achieve greater legislative independence for
the Irish parliament. Known as the Volunteer Gate (after one of
the period's local militias of which Lawrence was colonel), this
consists of a triumphal arch flanked by smaller openings which are
in turn connected to two-room lodges. A recessed panel directly
beneath the pediment bears a Latin inscription; translated this reads
'Liberty after a long servitude was won on the 16th April 1782 by
the armed sons of Hibernia, who with heroic fortitude, regained
their Ancient Laws and established their Ancient Independence.'

Bellevue having been abandoned at the start of the last
century and then demolished, the Volunteer Arch is the most
visible reminder of its former presence. A number of follies also
survive inside what was once the estate's demesne, such as this
eighteenth-century Gothick eyecatcher, photographed by Paddy
with members of the travelling community then in residence
nearby.

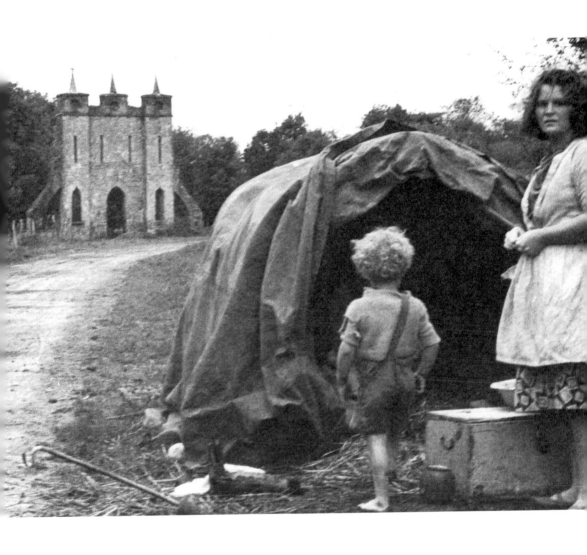

When Paddy visited Portumna Castle, it was suffering from serious neglect. However, the building has since undergone extensive restoration work, including being re-roofed, thanks to the Office of Public Works; it is now open to the public and hosts exhibitions and other events. The castle dates from 1618 when it was commissioned by Richard Burke, fourth Earl of Clanricarde, and his wife Frances Walsingham, who had previously been married to both Sir Philip Sidney and the second Earl of Essex. The building's design bears similarities to the Clanricardes' mansion at Somerhill, Kent, completed just a few years earlier. At the time it was probably the most sophisticated semi-fortified house in Ireland, with Italianate influences apparent throughout beginning with a Tuscan gateway providing access to the inner court. Few changes were made thereafter to the property, other than the addition of a bow at the centre of the rear elevation. However, Portumna Castle was accidentally gutted by fire in 1826 and the family later built a new residence on an adjacent site. The latter was destroyed in 1922 and its stones used to build a Roman Catholic church in the nearby town. The old castle was subsequently acquired by the state and, as mentioned, repaired although, having stood exposed to the elements for over 150 years, the interior retains few original features.

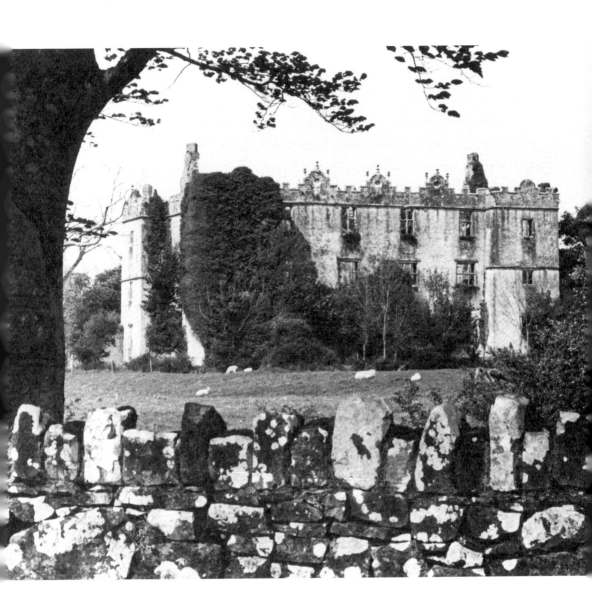

When visiting Tyrone House with her parents in September 1808, Louisa Beaufort described it as being 'a high house, standing on high ground; without a tree, bush or offices in sight, nothing can be more uncompromising than it looks from this road.' By this date the house was some thirty years old and one suspects that even when planting had taken place in the grounds, it always looked somewhat bleak and exposed on a site above Galway Bay. Tyrone was built around the time of his marriage in 1778 by Christopher St George whose family name was originally French but changed in order to benefit from a legacy. Its architect is unknown but on stylistic grounds the Waterford-resident John Roberts has been proposed for both this house and Moore Hall (*q.v.*). Housed in splendid surroundings (the entrance hall featured a life-size marble statue of an earlier generation in the guise of a Roman emperor) and benefitting from thousands of acres of land, the St Georges looked set for ongoing prosperity, but a series of mésalliances and financial misfortunes meant that by the end of the nineteenth century they had all-but abandoned Tyrone House. Eventually the building was gutted by fire during the War of Independence and has stood in ruin ever since, much of its cut stone pillaged despite supposedly being a property listed for protection.

Paddy's photograph, featuring a farmer ploughing a field in the foreground, demonstrates that Louisa Beaufort's description of Tyrone House remains as apt as when first written.

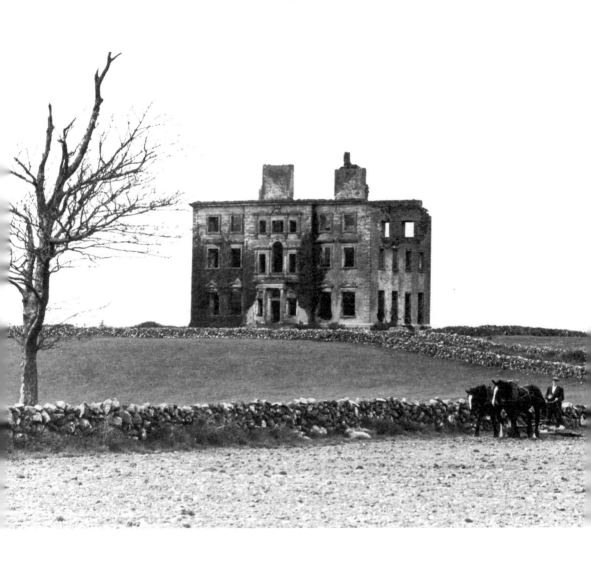

In 1786 George Powell, then visiting County Kildare, wrote:

> The Mansion House of Belan is most Magnificent as is also
> the Demesne thereto, containing 12 porters Lodges Erected
> by the present Earl at the six Approaches, who hath also
> added thereto a Fruitery, Green, Hot and Tea Houses, a
> Square of Offices, a Chappel & a Theatre & Expended near
> £8000 on the Estate.

The Earl in question was Edward Augustus Stratford, second Earl
of Aldborough, whose father was responsible for building the
now-lost Palladian house at Belan, its design attributed to either
Richard Castle or Francis Bindon. We know what the property
looked like thanks to its appearance in a couple of paintings, one
of which 'The Earl of Aldborough Reviewing Volunteers at Belan
House, County Kildare' (begun in 1782, now in the collection
of Waddesdon Manor, Buckinghamshire) shows its owner riding
his horse with the apt name Pomposo. Lord Aldborough had
architectural aspirations and was responsible for the construction
of both Stratford House (now the Oriental Club) in London and
Aldborough House in Dublin: the latter, the last aristocratic urban
palace to be built before the 1800 Act of Union, is now in perilous
condition. Meanwhile the greater part of Belan has almost entirely
gone, a portion of the stable block surviving to attest its vanished
splendour. Scattered about the surrounding fields, once parkland
but now given over to agriculture, are a handful of the former
follies and ornaments that once adorned the grounds, including
this obelisk.

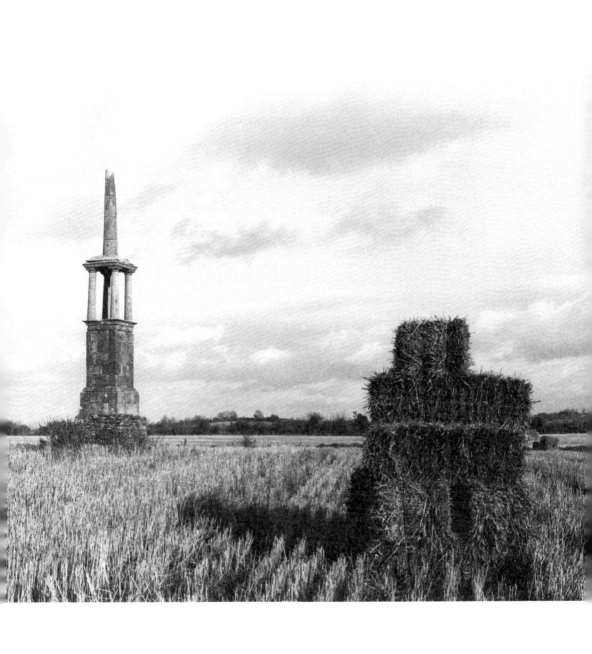

Located on what was once the outskirts of the village of Leixlip, Newtown Hill is a miniature Palladian villa dating from *c.*1765, its main block being of three bays and two storeys over basement, with a pedimented doorcase in the breakfront centre bay. On either side, single-storey, single-bay advanced blocks lead to wings taller than the links but not as high as the house, creating a modest forecourt. The front of each wing has a Venetian window on the ground floor and was originally roughcast. When Paddy photographed Newtown Hill it was still in single occupancy and surrounded by several acres of gardens. However, during the first decade of the present century the property was extensively refurbished, the house being divided into four apartments, while further residential accommodation was constructed in the remaining grounds to provide a total of twenty-one units, thereby fundamentally altering the character of the site.

The Blundens of Castle Blunden are descended from Overington Blunden, an English soldier who came to Ireland in the seventeenth century and in 1667 was granted lands by the crown in Counties Kilkenny, Tipperary, Offaly and Waterford. Castle Blunden dates from around the middle of the following century, and was most likely built, or at least commenced by John Blunden who sat as a Member of the Irish Parliament for Kilkenny City from 1727 until his death in 1752; his only surviving son, also called John and also an MP for the same constituency, would be created the first Blunden baronet in 1766. Its design attributed to amateur architect Francis Bindon, Castle Blunden is of seven bays and three storeys, its façade enlivened by an unusually wide pedimented portico supported by four Roman Doric columns. Above this is a niche containing a somewhat diminutive figure of a Roman general and then below the eaves a stone panel featuring the family coat of arms.

Paddy's photograph captures the charm of the building on a spring morning. Castle Blunden is a now-increasingly rare example of an Irish country house remaining in the possession of same family since first being built.

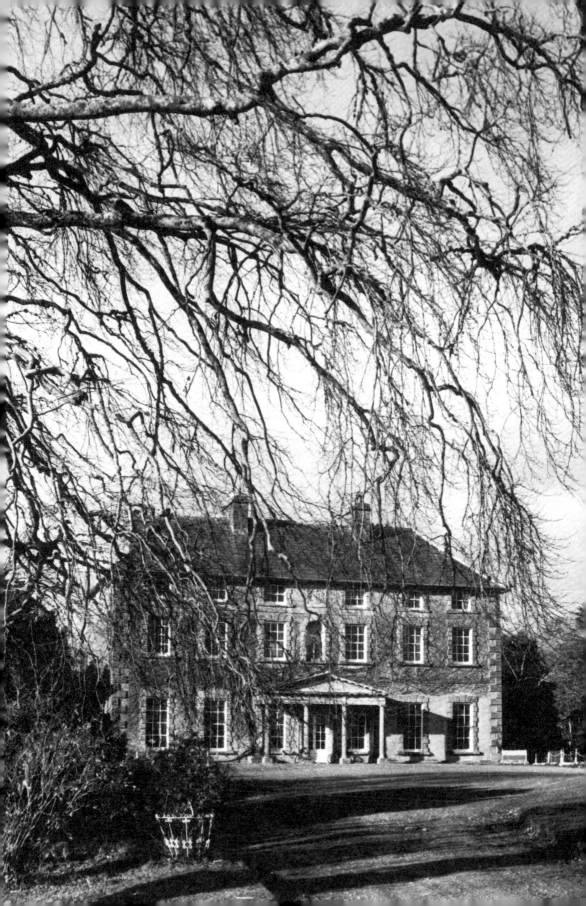

Paddy's photograph helps to explain why Castletown Cox has long been judged one of the loveliest country houses in Ireland. It was constructed 1767–71 for Michael Cox, then Archbishop of Cashel, a younger son of Sir Richard Cox, a lawyer who served as Lord Chancellor of Ireland (1703–07) and then later as Lord Chief Justice of the Queen's Bench for Ireland (1711–14). As was often the case with younger sons, Michael Cox entered the Established Church and rose through the hierarchy until appointed to the See of Cashel in 1754. He remained there for the next twenty-five years and although occupying the beautiful archiepiscopal palace designed some decades earlier by Sir Edward Lovett Pearce, embarked on the construction of Castletown Cox in order to leave his only son an estate and residence. The architect is believed to have been Davis Ducart, an engineer whose original name may have been Daviso de Arcort, and who may have come from Piedmont or Sardinia. A decade earlier he had designed Kilshannig, County Cork (*q.v.*), and in many respects Castletown Cox is a similar Palladian-style house with a centre block of three storeys over basement and seven bays, flanked by wings that are brought forward to create a semi-enclosed courtyard. Inside, as this photograph shows, the house features ravishing rococo plasterwork by Waterford stuccodore Patrick Osborne. Archbishop Cox's son had no heir and although it has changed hands on several occasions over the intervening 250-odd years, Castletown Cox has been subject to little intervention so that today it looks much as was the case when first constructed.

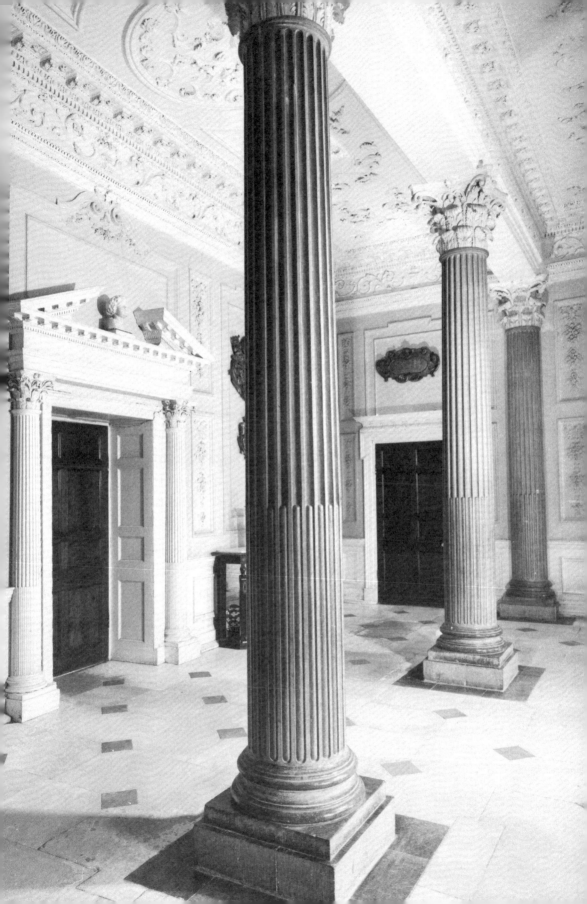

Mill Mount was the site of a marble works established in the early eighteenth century by local entrepreneur William Colles who invented machinery for sawing, boring and polishing stone, all of which formerly had to be done by hand; no doubt at least some of the Kilkenny marble chimney pieces seen in houses around the country came from his workshop as he had warehouse premises in Dublin. He is believed to have been the builder of several country houses such Bessborough and Woodstock, as well as the Tholsel in Kilkenny which he may also have designed. Following his death in 1770, the business was inherited by a son, also called William Colles, and he is said to have designed and built Mill Mount, presumably before his own death in 1779. Of cruciform plan, the house is of two storeys over raised basement. The single-bay façade features a substantial Venetian limestone doorcase and a diminutive Diocletian window inside the pediment at the top of the building. On either side large full-height bows swell out to give the building a more substantial appearance than would otherwise be the case.

Mill Mount survives to the present day and is still occupied, although its appearance has been marred by the insertion of inappropriate uPVC windows.

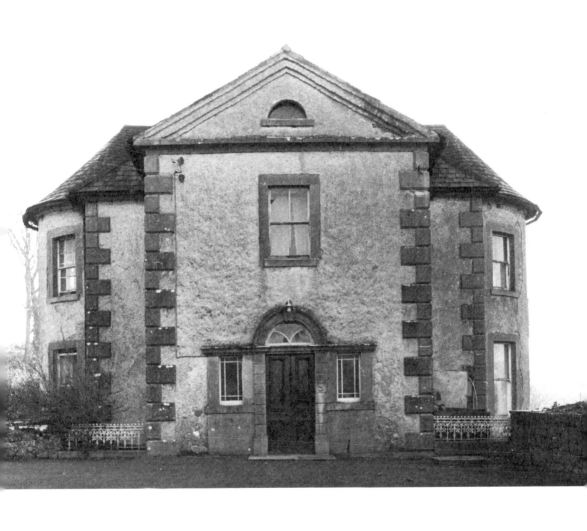

In 1745 Somerset Butler, eighth Viscount Ikerrin, married Juliana Boyle, daughter of Henry Boyle, then-Speaker of the Irish House of Commons and future first Earl of Shannon. Three years after his marriage, Butler was created Earl of Carrick and it was perhaps to mark this elevation that he embarked on building a new residence for himself across the River Nore from Ballylinch Castle where he and his family had hitherto lived. His wife was known as Juliet, and so when completed in the late 1760s the house was given the name by which it is still known, Mount Juliet: of three storeys over basement and with shallow bows at either end, the building was designed by an unknown architect. Irish country house owners frequently over-extended themselves when engaging in such large-scale projects, and this may explain why Mount Juliet's interior decoration was left to the next generation, the neo-classical plasterwork in the dining-room seen here dating from the 1780s. In 2007 on stylistic grounds the work was attributed to Dublin stuccodore Michael Stapleton.

Mount Juliet remained in the ownership of the Butler family until 1914 when it was sold to the McCalmonts who carried out some alterations, not least reorienting the entrance to the opposite side of the house. When Paddy photographed the building the McCalmonts were still in residence, but in 1989 the estate was bought by a number of investors and extensively developed as an hotel and golf resort.

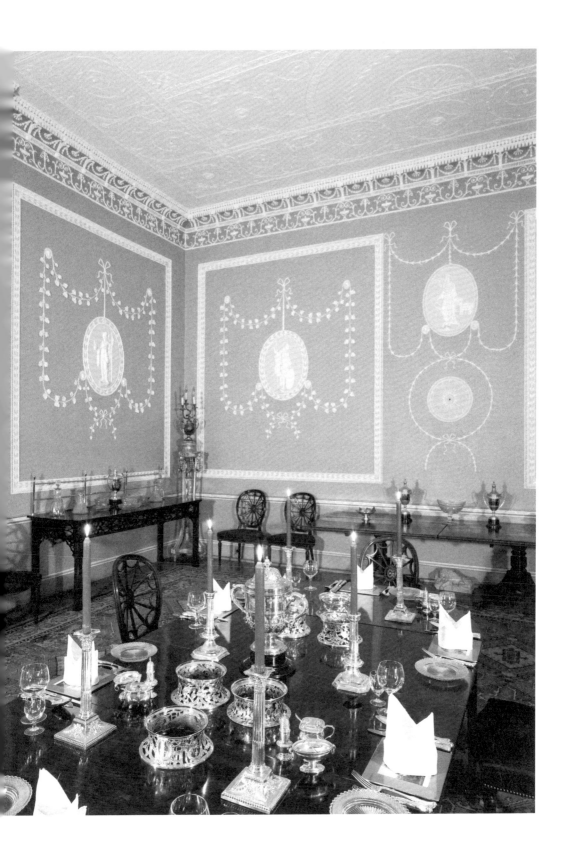

An ardent advocate of Ireland's architectural heritage, the late Desmond FitzGerald, Knight of Glin made his family home one of the best-known houses in the country. For some seven hundred years his ancestors had lived in the same area of County Limerick overlooking the Shannon estuary, tracing their origins to Maurice FitzGerald, son of Gerald FitzWalter of Windsor and his wife the Welsh Princess Nesta. In 1169 Maurice participated with Richard de Clare, Earl of Pembroke (otherwise known as Strongbow) in the Norman invasion of Ireland and thereafter remained in the country. It has been proposed the title Knight of Glin was bestowed on John FitzJohn by his kinsman John FitzThomas who in 1316 was ennobled as first Earl of Kildare. Thereafter although not recognized in the British peerage, the Knighthood of Glin was inherited by prescriptive right until the death of Desmond FitzGerald in 2011. Before the late seventeenth century successive knights were perforce warriors and the oldest part of the present castle, a long thatched house, dates from the close of that period. Colonel John Bateman FitzGerald, twenty-third Knight of Glin in the 1780s decided it was time to build something more splendid for himself and his descendants, and therefore commissioned the large three-storey block that on the ground floor contains the entrance and staircase halls as well as drawing-room and library. Although he married an heiress, there were still not sufficient funds to complete the interior, and it was only thanks to Desmond FitzGerald and his wife Olda that the top floor of the castle was finally decorated. Following his death, it seemed unlikely that the family would continue to live in their ancient home. However, more recently the Knight's eldest daughter Catherine FitzGerald and her husband, actor Dominic West, have taken on responsibility for Glin Castle and intend to ensure its future.

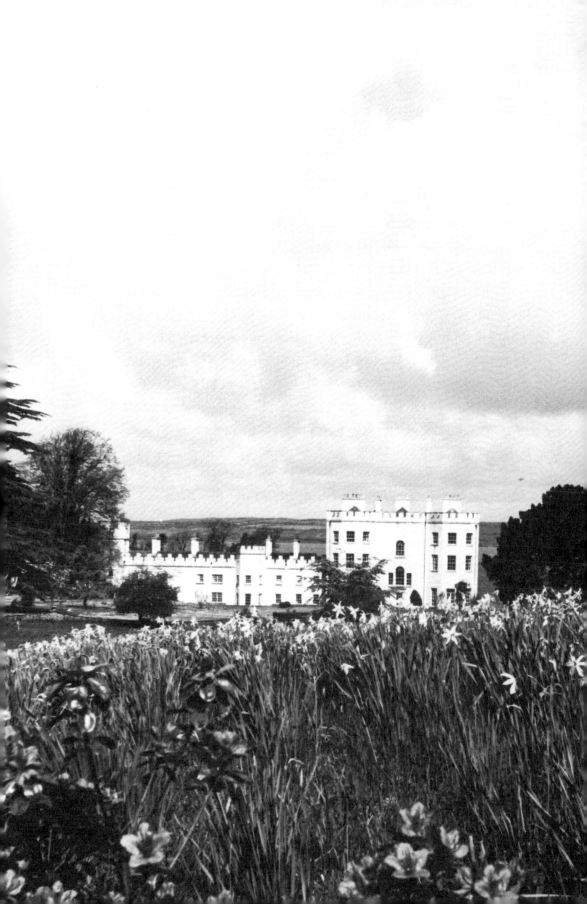

Looking at Paddy's photograph of Ledwithstown, it is easy to imagine that the house was on the verge of being lost. In fact, this is far from being the case. Here is an instance of rescue and restoration, and today Ledwithstown is a much-loved family home. Its design attributed to Richard Castle, this mid-eighteenth-century miniature country house (its outer walls measure 48 by 47 feet), was owned until early in the last century by the Ledwith family about whom little is known other than they settled in this part of the country around 1650 and were gentlemen farmers. Ledwithstown was bought by Laurence Feeney in 1911. However, following his premature death just six years later, the house was let to a variety of tenants none of whom took care of the property; seemingly a brother and sister living there for a while removed all the door and shutter knobs, while another family allowed the chimneys to become blocked and then knocked holes in the walls to permit smoke escape. In 1976 Maurice Craig described Ledwithstown as being 'unhappily in an advanced state of dilapidation, perhaps not beyond recovery' and two years later Mark Bence-Jones wrote that the place was 'now derelict'. However, around this time the original Laurence Feeney's grandson, likewise called Laurence, married and he and his wife Mary began to consider the possibility of restoring Ledwithstown.

The couple, together with their children, initiated work on the house and in 1982 they were visited by Desmond Guinness. Soon afterwards the Irish Georgian Society offered its first grant to Ledwithstown, the money being put towards replacing the roof. Further financial aid from the IGS followed, along with voluntary work parties to help the Feeneys in their enterprise. The family remains in residence and looks set to do so for many years to come.

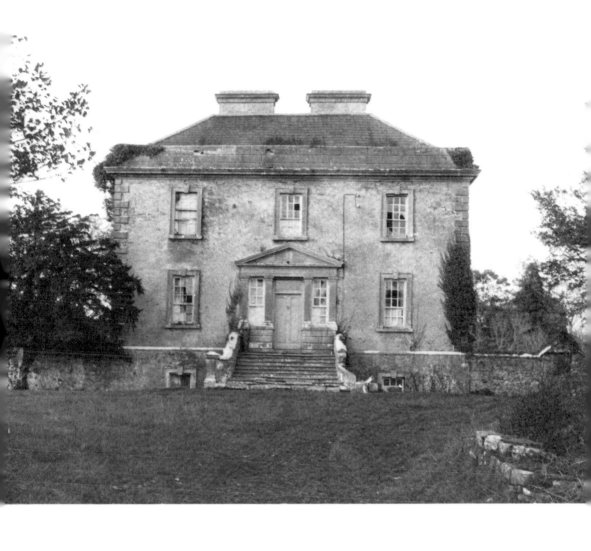

The original house at Hollymount is believed to have been built by John Vesey who, like his father and grandfather, and in turn his own eldest son, was a clergyman in the Established Church. Born in Coleraine, County Derry, in 1638, he rose through the clerical hierarchy, becoming Bishop of Limerick in 1673 and Archbishop of Tuam six years later. Fleeing to London during the Williamite Wars, on his return he not only undertook restoration work on the badly damaged cathedral in Tuam, and built himself a new country residence at Hollymount; nothing is known of this building and its appearance but a church in the adjacent village, albeit modified in the nineteenth century, still stands. The Veseys transferring their landed interests to County Laois, where the archbishop's grandson would build Abbey Leix and his great-grandson become first Viscount de Vesci, Hollymount later passed into the ownership of the Lindsey family. The house was substantially altered by architect George Papworth in the mid-1830s.

Sold by the Lindseys in 1915 and vacated a few years later, it was derelict within a couple of decades and then fell into complete ruin, so that little is now left. This splendid urn atop a gate pier gives an indication of how fine the estate must once have looked. The rusticated gate piers were moved to Kinsale, County Cork, where they can be seen at the entrance to St Multose's church, but without the original urns on top.

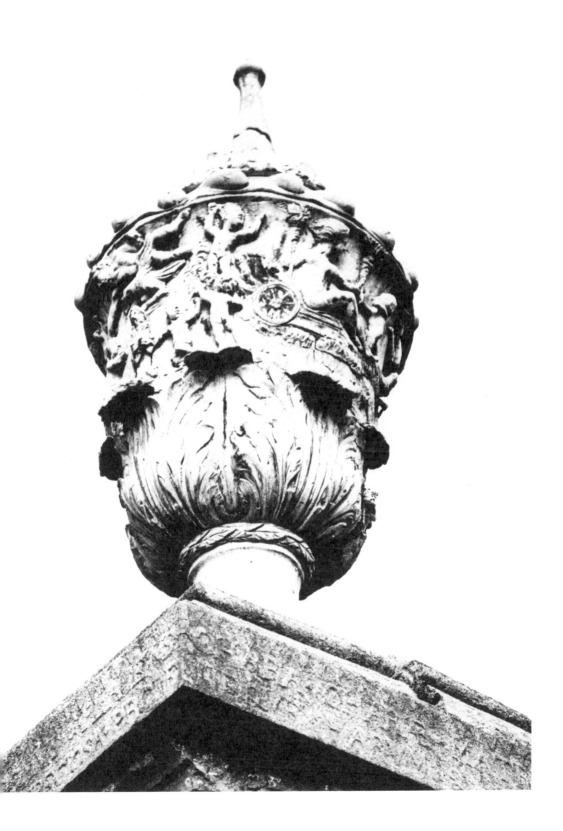

In the mid-eighteenth century Galway merchant George Moore emigrated to Spain to trade in wine and brandy. He also manufactured iodine, a valuable commodity at the time, and shipped seaweed from Galway for its production, owning a fleet of vessels for this purpose. Having made his fortune Moore then returned to his native country and bought an estate of some 12,500 acres in County Mayo. Here he built a house, accredited on stylistic grounds to Waterford architect John Roberts: its position was selected to enjoy views across Lough Carra and the prospect of Ballinrobe's spires in the far distance. Fronted in cut limestone, Moore Hall stands three storeys over sunken basement, the façade centred on a single-bay breakfront with tetrastyle Doric portico below the first floor Venetian window. A date stone indicates it was completed in 1795, three years before Ireland erupted in rebellion. Among those who took part was George Moore's eldest son John who after being schooled at Douai had studied law in Paris and London, returning to Ireland to join the uprising. On 31 August 1798 the French general Jean Joseph Humbert, who had landed at Killala a week earlier, issued a decree proclaiming John Moore President of the Government of the Province of Connacht. Within weeks, however, the British authorities had crushed the rebellion and captured Moore who died the following year en route to the east coast where he was due to be deported. George Moore, who had spent some £2500 attempting to secure his heir's release, had died just a month earlier.

Despite these impeccable republican credentials, and the Moores' tireless work to ensure the survival of their tenants during the Great Famine of the 1840s, Moore Hall was burnt by

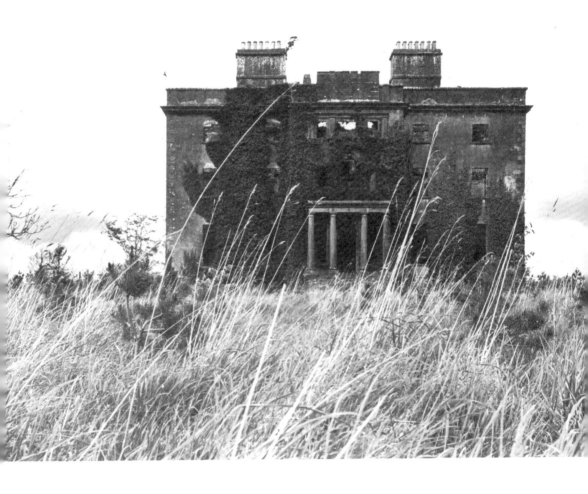

incendiaries in the Civil War. It has remained a shell ever since, and even the view of Lough Carra, still visible when Paddy took this photograph, was lost as the house became surrounded by thick woodland. In January 2018 it was announced that Mayo County Council had bought the property and surrounding eighty acres to develop as a nature reserve and tourist attraction.

This is one of a number of follies created at Neale Park, County Mayo, long-time seat of a branch of the Browne family, created Barons Kilmaine in 1789. Known as the Temple of the Winds, it is of relatively late date, some of the other buildings in the park dating to the eighteenth century: there is, for example, a stepped pyramid some thirty feet high erected by the first Lord Kilmaine, seemingly to a design of his brother-in-law, the architecture-loving first Earl of Charlemont. Dating from 1865, the hexagonal temple rests on the vaults of an earlier, unfinished tower and it is unclear whether the later structure was also ever completed, since it lacks a roof. Six limestone Doric columns support a carved entablature, supposedly providing a spot to which the ladies of the house could walk. They were able to do so until 1925 when Neale Park was sold and the demesne divided up: the greater part of the house was demolished in 1939 and the surviving wing is now a roofless shell. This folly and its fellows provide the only reminders of the former Browne estate.

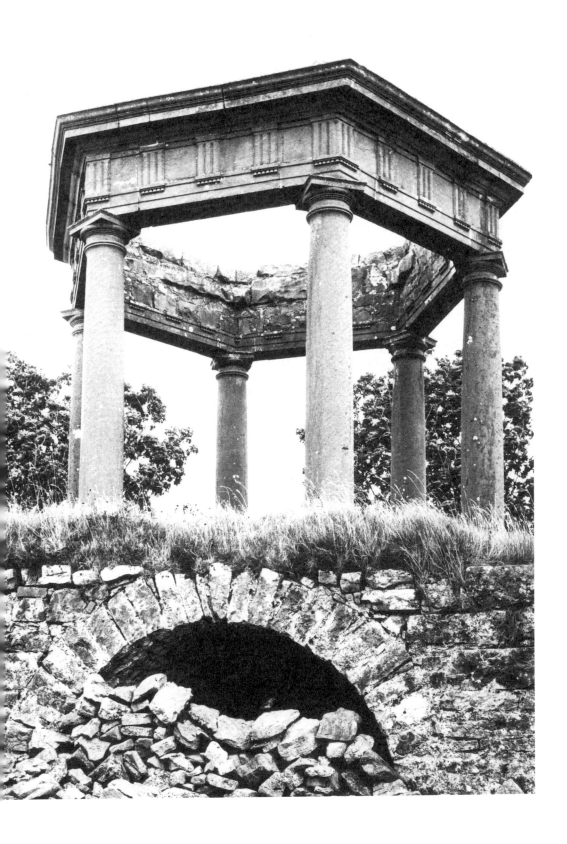

The childhood home of the first Duke of Wellington, in the eighteenth century, Dangan was celebrated for its elaborate demesne, created by Richard Wellesley, first Baron Mornington and then his son, the music-loving Garret Wellesley, who in 1760 was created first Earl of Mornington. His god-mother Mary Delany often visited the estate and in her letters has left vivid descriptions of its grounds and the house then standing in the middle. The original Dangan Castle she called 'large, handsome and convenient' with an organ and harpsichord in its large entrance hall. Following a fire in the 1740s, the building was reconstructed and, in so far as one can tell from the shell that still stands, was a substantial but fairly plain block. Outside there were formal gardens containing carefully planted allées and canals, on one of which floated a model of George II's yacht, *The Caroline*. Elsewhere, according to Mrs Delany:

> There is a fir-grove dedicated to Vesta, in the midst of which is her statue; at some distance from it is a mound covered with evergreens, on which is placed a Temple with the statues of Apollo, Neptune, Proserpine, Diana, all have honours paid to them and Fame has been too good a friend to the mentor of all these improvements to be neglected; her Temple is near the house, at the end of the terrace near where The Four Seasons take their stand, very well represented by Flora, Ceres, Bacchus and an old gentleman with a hood on his head, warming his hands over a fire.

Almost all has since disappeared: Dangan was sold by the family in 1793 and like its predecessor the house was destroyed by fire

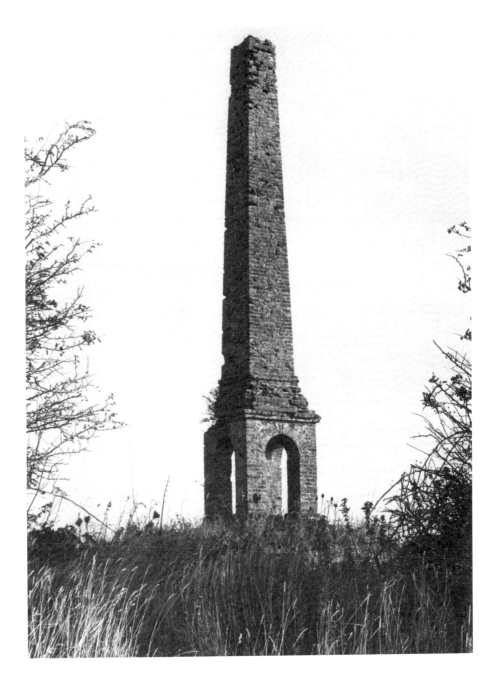

in 1809, on this occasion not to be rebuilt. Only two of the obelisks that were once features of the garden survive. This one was photographed by Paddy when still in ruinous condition but in 2015 a group of locals raised funds to restore the monument in commemoration of the bicentenary of the Battle of Waterloo.

The name Dollardstown derives from Adam and Paganus Dullard who in 1175 were granted lands in this part of the country by the Anglo-Norman Hugh de Lacy, Lord of Meath. In the late seventeenth century, Dollardstown was acquired by Arthur Meredith, whose forbear the Welsh-born cleric Richard Meredyth in 1584 moved to Ireland where he became Bishop of Leighlin and Dean of St Patrick's, Dublin. It seems likely that the house at Dollardstown was at least in part of seventeenth-century origin, but after the estate was inherited by Arthur Meredith's son (also called Arthur) in 1732 he rebuilt the property, apparently to the designs of Richard Castle. From the 1830s onwards, it seems that Dollardstown passed through various hands: in the last century, it was home to the mother of *Financial Times* founder and politician Brendan Bracken following her marriage to Patrick Laffan who then owned the house: she described it as 'that old barracks'. Of seven bays and three storeys, the house had tall free-standing pavilions on either side: one of these still survives. An architectural curiosity was that both side elevations had paired Venetian windows on ground and first floors. Inside, the main rooms had plaster panelling and there was a fine staircase. All remained in place as late as the 1950s when the building still had its roof but by the time Paddy visited, it was already falling into ruin. Dollardstown was demolished in 1986 although the main doorcase and some other elements were rescued.

Writing in the Irish Georgian Society's *Bulletin* in 1967, the Knight
of Glin proposed that part-time architect, painter and politician
Francis Bindon had been responsible for the design of Drewstown,
built in the 1740s. However, looking at the house the impression
is given that someone even more amateur than Bindon, who had
considerable understanding of classical architecture, was responsible
here, perhaps Robert King who commissioned its construction.
The entrance hall is a case in point. Although clearly indebted to
the Queen's House, Greenwich designed by Inigo Jones more than
a century earlier, the hall's execution is somewhat cack-handed.
The space is a large square with the stairs to the rear leading to a
gallery that runs around the entire first floor. But the proportions
are miscalculated, as the segmental-headed door pediments hit
both the cornice and the underside of the gallery. Furthermore,
inside the hall the entrance itself is slightly off-centre leading to
an adjacent window being partially concealed by the wall of the
adjoining room.

Its amateurishness is part of Drewstown's charm, as is
evident in this picture. The house happily survives, today used as a
Christian retreat centre.

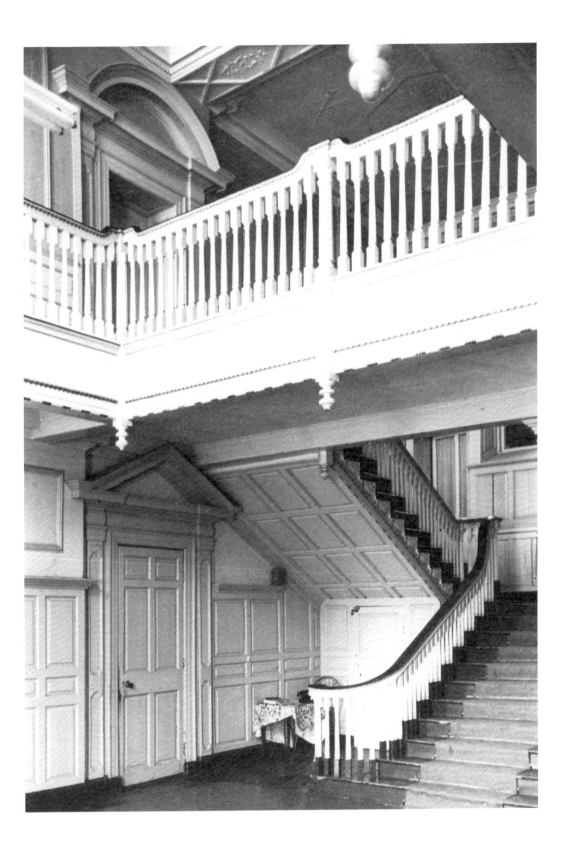

Occupied until just a few years ago, Duleek House now looks very much worse than when photographed by Paddy. Although this is not apparent from the front, the building dates from two periods, the section to the rear being the older and possibly dating from the seventeenth century. Around 1750 Thomas Trotter, a judge and also local Member of Parliament, decided to double the house's size. A new façade was constructed, of three bays and three storeys, all in limestone ashlar with a projecting centre bay that features a tripartite Doric doorcase with pediment on the ground floor. Above this is a handsome Venetian window and on the top floor a tripartite window, the whole crowned with another pediment. On stylistic grounds, the work has been attributed to Richard Castle. Inside, the entrance hall had Doric columns and to the rear three timber arches with the staircase rising behind the centre one.

How much, if any of this, survives is impossible to say, since Duleek House has stood empty and falling into decay for some years, and the site is now dangerous to enter: a sad loss to the country's architectural heritage.

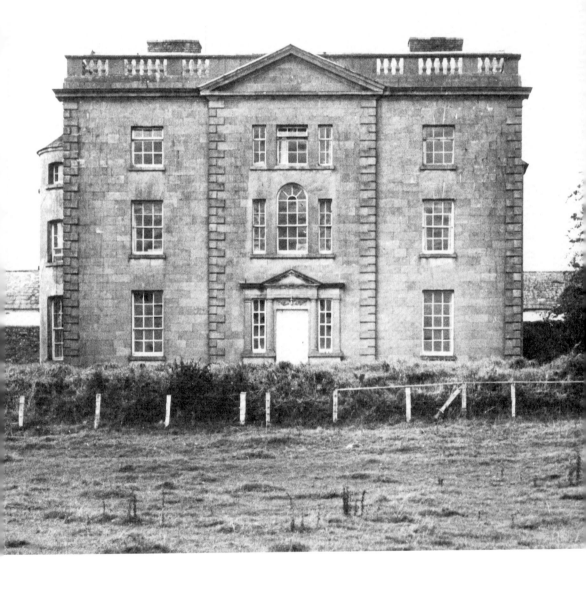

The Plunketts are one of the oldest Anglo-Norman families in Ireland, and one of the very few still living in the same part of the country. Dunsany Castle passed into their possession through marriage in the early fifteenth century, probably not long before Christopher Plunkett was created first Baron of Dunsany. A castle is thought to have been constructed here by Hugh de Lacy in the twelfth century but the present building is likely later, again from around the time of the Plunketts' acquisition. Major alterations took place in the late eighteenth and early nineteenth century, and the library dates from the latter period, its design attributed to James Shiel who carried out not-dissimilar work at nearby Killeen Castle for the fourteenth Lord Dunsany's cousin, James Plunkett, Earl of Fingall.

The room has changed little since then, its ceiling an elaborate arrangement of diamonds and octagons leading to no fewer than thirty-six ribbed brackets running around the walls, with Gothic-style grained oak bookcases beneath. Paddy's photograph perfectly captures the room's distinctive, mellow charm.

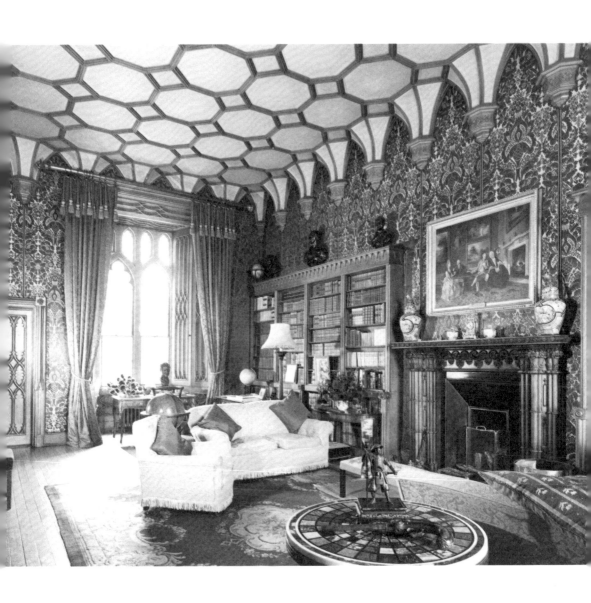

Johnsbrook represents the ideal of a medium-sized Irish Georgian house, suitable as residence for a gentleman farmer: a fine yard lies directly to the rear. Believed to date from *c.*1770, it was built for the Tandy family and remained in their possession until the last century. In August 1879, then-owner of the property Thomas Tandy was discovered in a ditch on his land, having been shot in the head and spine: his murderer was never discovered. Of two storeys over raised basement, it has a five-bay façade with breakfront centre bay defined by quoins. Above is a pediment containing a Diocletian window to light the attic. A limestone pedimented doorcase flanked by Doric columns is approached by a short flight of stone steps. Paddy's photograph shows the house in poor condition, with sections of the render missing and windows falling into disrepair. It was subsequently restored and is today a family home.

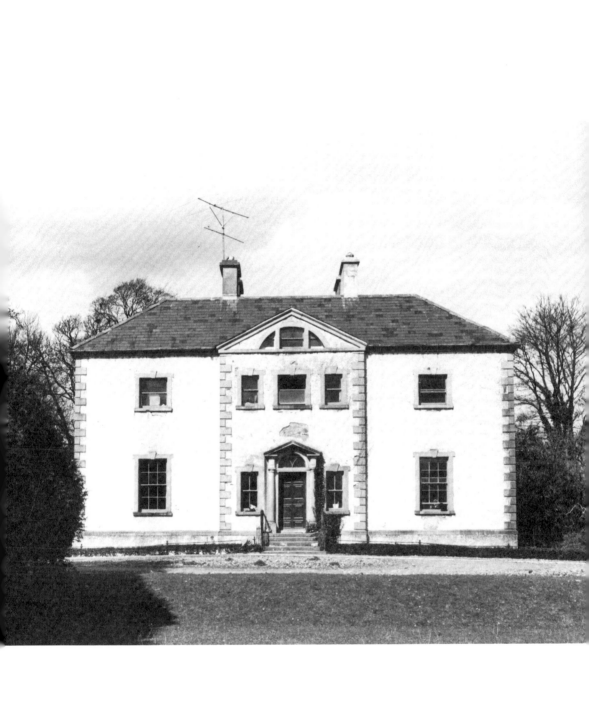

Killeen Castle was the sister-house to Dunsany Castle (*q.v.*), but
has enjoyed a less happy fate, having fallen into near-ruin in the
second half of the last century. As with Dunsany, the original
castle was built by another Anglo-Norman family, the de Cusacks,
and passed into their possession following the marriage in 1399
of Christopher Plunkett, future first Baron Killeen, to Joan de
Cusack. It was one of the couple's sons who became first Baron of
Dunsany, while in 1628 the tenth Baron Killeen was created Earl
of Fingall, a title that survived until the death of the twelfth earl in
1984. Some decades before then the castle had passed out of family
ownership, having been sold in 1951, its contents being disposed
of a few years later. After passing through the hands of a couple
more owners, Killeen Castle was gutted having been needlessly set
on fire by the IRA. Again, as with Dunsany, much of the building
had been altered in the first decades of the nineteenth century,
first by Francis Johnston and then by by James Shiel. One of the
latter's most striking interventions was the entrance hall seen here.
Beneath an elaborate Perpendicular Gothic ceiling rose the main
staircase leading to a recessed arcade: turning around, one saw a
series of arched niches containing the family coats of arms.

All of this was lost in the fire, and subsequent neglect of the
building even as the surrounding park was turned into a golf course.
In May 2018 plans were announced to turn Killeen Castle into a
luxury hotel and spa, with an extension holding 160 bedrooms.

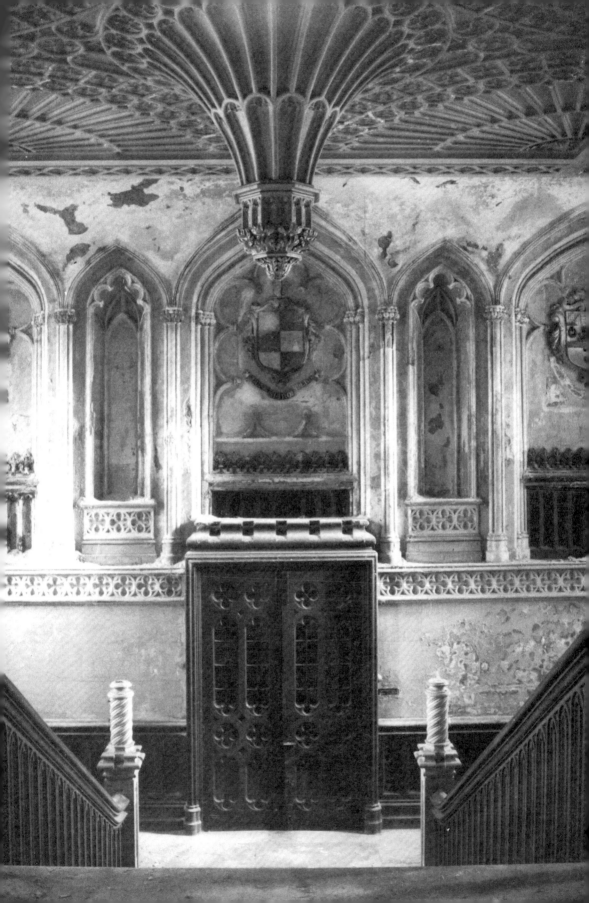

Platten Hall was still very much intact when Thomas U. Sadleir and architect Page L. Dickinson published *Georgian Mansions of Ireland* in 1915. Thanks to their description of the building, and accompanying photographs, we know how the building looked, not least its double-height entrance hall:

> which contains a handsome grand staircase in three flights, supported by six Ionic columns, the floor being paved in black and white marble. The walls are panelled, and there are other symptoms of early construction; there is some tasteful decoration, the frieze being very richly carved, and displaying tiny figures, quite Jacobean in treatment. Note, too, the gallery, which we also illustrate, with its handsome balustrading, with ramps at the newels. Below the gallery the panels are in plaster.

Built *c.*1700 for Alderman John Graham of Drogheda, the design of Platten Hall was attributed by Maurice Craig to Sir William Robinson. Alas, we shall never know as the house was demolished in the early 1950s. By the time Paddy got to the site, only the outbuildings still stood but they were almost as handsome as the house they were intended to serve. His photograph provides a tantalizing hint of what had been lost.

Springvalley rose to the immediate south-west of one of the country's most outstanding eighteenth-century houses, Summerhill. The latter was a palatial mansion dating from the 1730s and probably designed by Sir Edward Lovett Pearce, its appearance owing something to Pearce's relation Vanbrugh, with whom he had trained. It was burnt in 1921 and the ruins demolished some thirty years later, although not before being photographed by the late Maurice Craig.

Paddy's picture of the entrance to neighbouring Springvalley shows another now-lost view. The house may have been built by George Dennis who was buried not far away at Agher: by the end of the eighteenth century it was occupied by his granddaughter Elizabeth Bryan. It has since disappeared, as has the entrance seen here. The thatched cottage went first but the tall limestone Corinthian columns, rather out of their scale suggesting they may have been brought from Summerhill after its destruction by fire, survived for longer. They disappeared a few years ago and now nothing remains to indicate a significant property once stood on this site.

Talbot's Castle is not, of course, a castle at all, nor indeed does it appear the building was erected by the man after whom it is named, Sir John Talbot, who for five years from 1414 served as Lord Lieutenant of Ireland. In fact, it was part of St Mary's Abbey, an Augustinian house famed for containing a miraculous statue of the Virgin that attracted pilgrims to the site. The buildings here were almost totally destroyed by fire in 1368, and there followed a long period of reconstruction that would still have been ongoing when Talbot was in the country: this explains the presence of his coat of arms on a limestone plaque set into the north wall at the west end of the structure. Internal evidence indicates that the main block of Talbot's Castle was in fact the Augustinians' refectory, to which a tower was added at the west end, perhaps in the Lord Lieutenant's time when religious establishments were vulnerable to attack. In the aftermath of the sixteenth-century Reformation, much of St Mary's gradually fell into ruin: a vast steeple (seen on the right of this photograph) is all that remains of the abbey church. This building however, later became the Diocesan School of Meath, serving this purpose during the eighteenth and nineteenth centuries. Around 1909 the property underwent substantial alterations commissioned by then-owner Archibald Montgomery, who among other work added an attic storey to the west-end tower.

Talbot's Castle remains a private residence to the present day but the best view of the building is as taken by Paddy, looking across the River Boyne towards its south-west front whence gardens descend to the water.

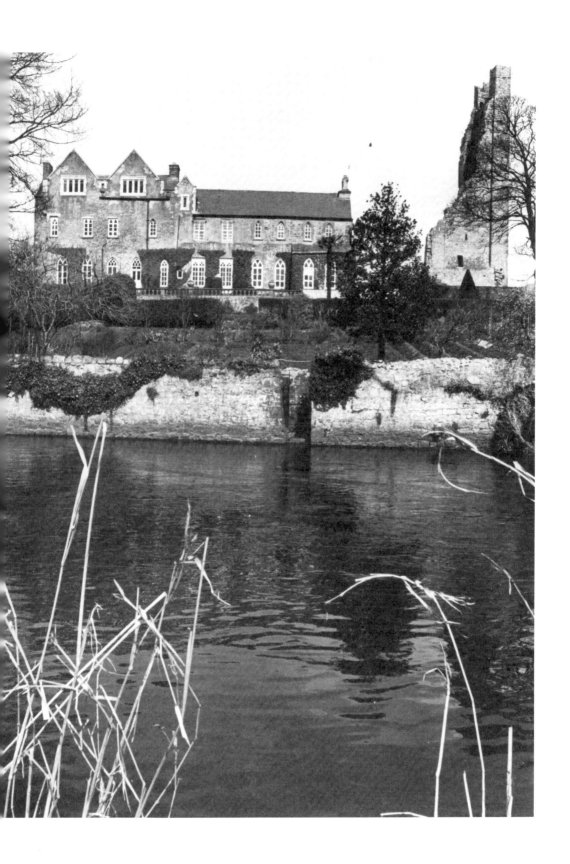

Charles William Bury was not yet two months old in August 1764 when his father John died, and he inherited both the paternal estates and those of his great-uncle Charles Moore, Earl of Charleville. The latter owned large swathes of land close to Tullamore, County Offaly, where a house called Redwood had been built by the Moores in the seventeenth century. Soon after Charles Bury's marriage to Catherine Dawson in 1798, the decision was taken to construct a new residence on another site and Francis Johnston invited to submit designs.

Johnston, one of the most talented and versatile architects of his own or any age, is today best-known for superlative neo-classical works like Townley Hall, County Louth (built 1794–98) and the General Post Office in Dublin (1814–18). However, he was also able to design in the increasingly fashionable Gothic style, and this was the choice of Charles Bury.

Begun in 1801 and completed in 1812, Charleville Castle is widely judged to be Johnston's Gothic masterpiece, a vast battlemented block, with a heavy octagonal tower on one side of the entrance front and a slender round tower on the other. Inside, a powerful impression is immediately made by the staircase climbing up to a series of splendid reception rooms on the first floor.

Bury was created Earl of Charleville in 1806 but the title died out less than seventy years later, and Charleville Forest passed through various other branches of the family but remained empty and unoccupied for long periods during the last century. Although still in need of conservation work, the building is managed by a charity, the Charleville Castle Heritage Trust, and open to the public.

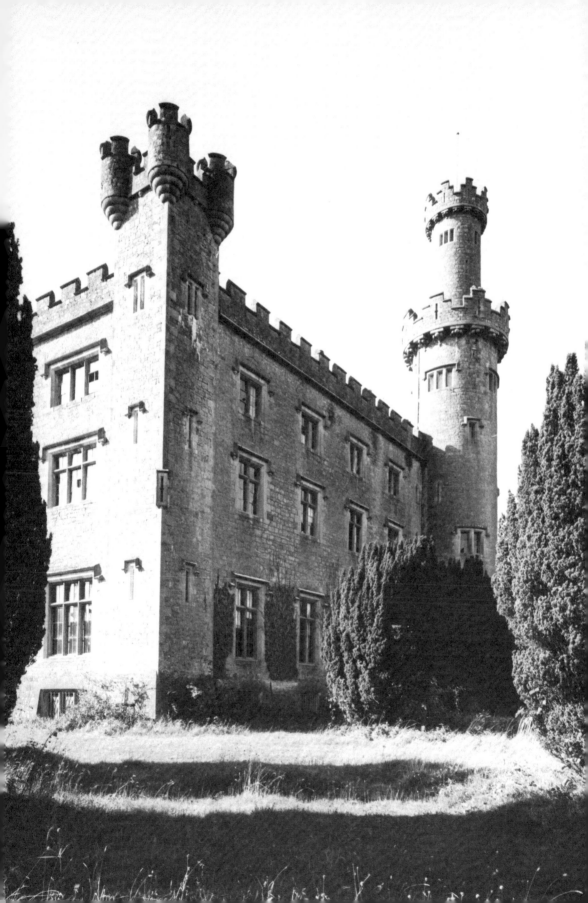

It is very large and looks externally like a gentleman's country-seat – within most of the rooms are lofty and spacious, and some – the drawing-room, dining-room &c handsomely and commodiously furnished. The passages look desolate and bare – our bedroom, a great room of the ground floor, would have looked gloomy when we were shown into it but for the turf fire that was burning in the wide open chimney.

So wrote Charlotte Brontë of Cuba Court in July 1854. The novelist spent part of her honeymoon in the house, where her husband the Rev. Arthur Bell Nicholls, had passed his childhood. By that time Cuba Court had become a school, having been purchased for this purpose in 1822 by the Rev. Nicholls' uncle Dr Alan Bell. However, originally it was a private residence, believed to date from the early eighteenth century. It has often been suggested that Sir Edward Lovett Pearce was involved in the design of what the late Maurice Craig described as 'perhaps the most splendidly masculine house in the whole country'. Cuba Court was U-shaped, with two wings projecting north on either side of a narrow rear courtyard. The south-facing façade had a large pedimented door reached via a flight of steps and with a quasi-Venetian window on the first floor. Curiously the west front also had a substantial doorcase with tapering pilasters, inspired by one designed by Vanbrugh at King's Weston in Bristol but deriving from the work of Michelangelo.

King's Weston still stands but, despite its literary associations, Cuba Court was unroofed in 1946 and began to fall into decay: Paddy's photograph, taken through the entrance gates, shows the house still standing but the remains have since been demolished.

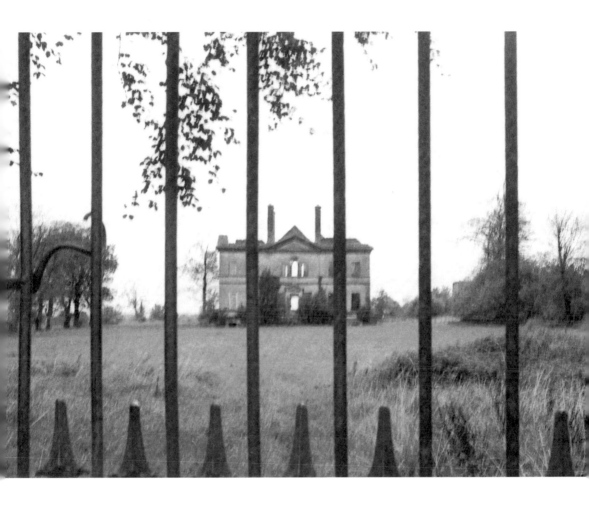

Gloster is believed to date from the third decade of the eighteenth century and to have been designed by Sir Edward Lovett Pearce, a cousin of then-owner Trevor Lloyd. The original two-storey building was of nine bays but two more were later added on either side making the façade exceptionally long. A series of terraces in front of the building drop away to a lake and then the view gradually ascends to close with the distant prospect of the Slieve Bloom Mountains, while to one side another vista terminates with a rustic arch flanked by obelisks. The sense of baroque theatre evident in Gloster's situation continues indoors, not least thanks to its spectacular double-height entrance hall, on either side of which run a sequence of rooms providing a wonderful enfilade rarely found in Ireland. In similarly dramatic fashion, immediately behind the hall a pair of staircases provides access to the first-floor gallery seen here, in which mirrors over facing chimneypieces play tricks with perspective.

Gloster remained in the ownership of the Lloyds until 1958 when it was sold to the Salesian order of nuns who opened a convalescent home in the house and built a large school to the rear. However, in 1990 they closed down operations and the building's future looked uncertain, especially since it then changed hands on a couple of occasions. Thankfully the present owners bought the place in 2001 and since then have worked tirelessly to improve Gloster's condition. Inevitably, given the scale of the undertaking, this remains a work in progress but already an enormous programme of restoration and refurbishment has been undertaken.

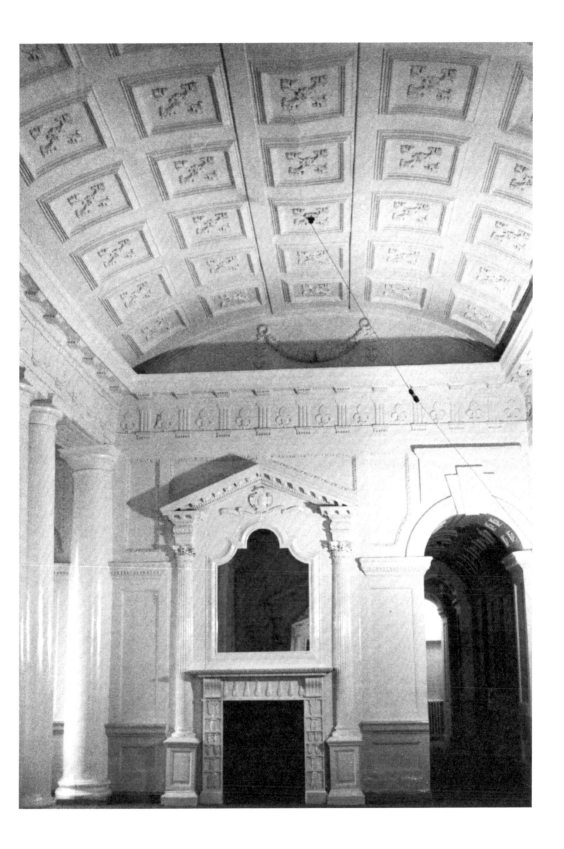

Boyle, County Roscommon, is a provincial market town, seemingly indistinguishable from many others throughout the country, except for an immense house reminiscent of the seigneurial chateaux one finds in regional French urban centres. Of three storeys over basement, King House was built for Sir Henry King, dates from 1720–30 and is believed to occupy the site of an earlier structure. As so often, the architect responsible is unknown. Both Pearce and Castle have been mentioned, but so too has William Halfpenny (d.1755), an Englishman who worked in Ireland during the 1730s in Dublin, Hillsborough, County Down, and Waterford City. Not a lot of the original interior remains.

The Kings occupied their house for little more than half a century before it was damaged by fire in 1788. By this date tastes had changed and it was considered more desirable to reside in the countryside, so the family moved to the nearby estate of Rockingham. King House was first leased and then in 1795 sold for £3000 to the government. Subsequently it was converted into an army barracks and during the nineteenth century was occupied by the Connaught Rangers.

Following Independence, the building continued to serve the same purpose for members of the Free State Army until the 1960s when King House passed into private hands and was used as a store and fuel depot; it was during this period that Paddy photographed the building. King House's condition deteriorated further and by the 1970s tenders were invited for the building's demolition to make way for a car park. Thankfully in 1987 it was acquired by Roscommon County Council with a full programme of restoration work beginning two years later. Today King House operates as a museum and cultural centre.

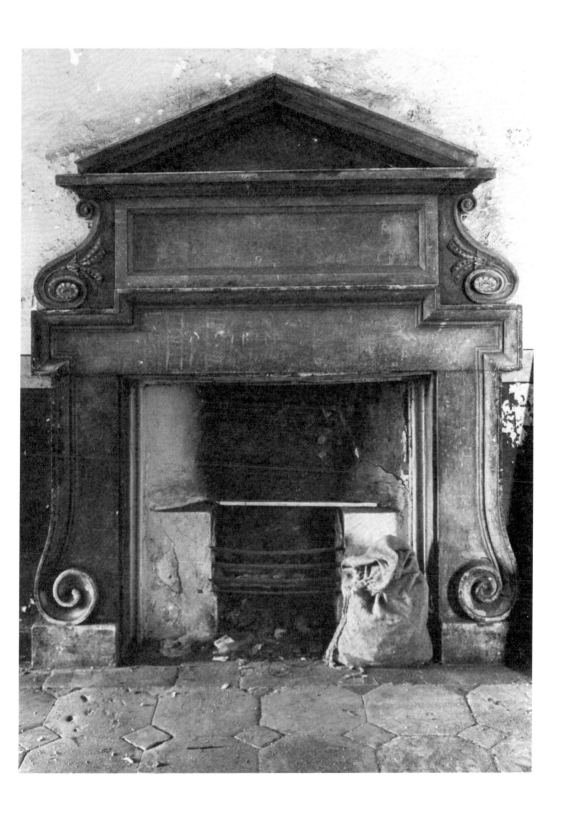

Relatively few early eighteenth-century houses have survived and remain occupied in Ireland, which makes Mount Falcon all the more precious. It appears to have been built for one Richard Falkiner (b.1691) whose Yorkshire-born father had moved to Ireland. In the pediment of the house's façade are carved the initials RFM and the date 1720: the latter is the year Richard Falkiner married Maria Rogers whose parents were settled nearby at Ballynavin, County Tipperary. Thus Mount Falcon is presumed to have been built at the time of the Falkiner marriage, although Richard would die just thirteen years later leaving the estate to his twelve-year old heir, also called Richard. Mount Falcon is relatively unsophisticated in design while showing awareness of contemporary trends in architecture. Of two storeys over semi-raised basement and with five bays, it is a relatively shallow house (there is an extension to the rear to create a T-shape) with broad gables carrying chimneys at either end. The façade is distinguished by a Gibbsian door reached by a flight of limestone stone steps and at the top of the building a pediment with an arched attic window flanked by shallow paterae, the whole topped by a ball finial (with two more at either end of the frontage). The balustrade and window ornamentation look to be later additions but otherwise Mount Falcon is an excellent example of the kind of residence built by members of the Irish gentry once peace settled over the country in the eighteenth century.

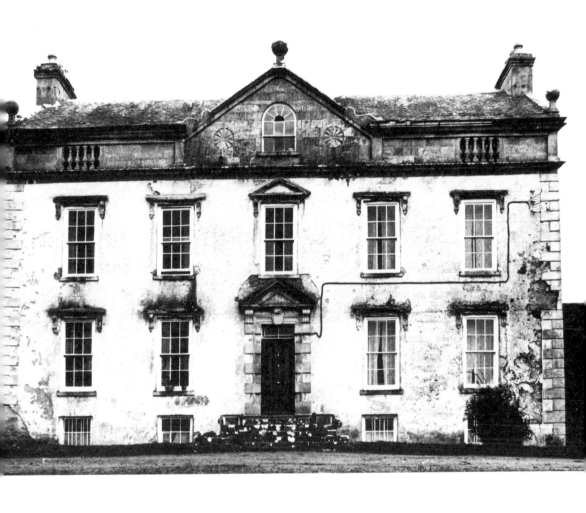

Petersfield, otherwise known as Johnstown Park, was built by a branch of the Holmes family in the late eighteenth century. It is unclear whether these Holmeses were related to others of the same name in County Antrim who were of Irish descent (their surname being an Anglicized version of Mac Thómais). They were certainly settled in this part of the country by the early eighteenth century since in 1728 Peter Holmes of Cullen, County Offaly, paid £4437 for 540 acres of what would become the Petersfield estate. It was his grandson, another Peter, who served as MP in the Irish Parliament for Banagher, County Offaly, and who built the house and named it after himself. The architect is believed to have been the amateur William Leeson, best-remembered for laying out the town of Westport, County Mayo, for John Browne, first Earl of Altamont. Perhaps related to the family of the same surname who became Earls of Milltown and lived at Russborough, County Wicklow, William Leeson, lived in north County Tipperary and seems to have designed a number of houses in the area including Prior Park (*q.v.*) and Petersfield. The latter was a tall block of three storeys over raised basement and of five bays, the three centre ones being closely bunched together. Only a pedimented doorcase with engaged Tuscan columns broke the otherwise-plain façade. The interior seemingly contained good neo-classical plasterwork but no known photographs of it survive. Peter Holmes and his wife Elizabeth Prittie (a sister of the first Lord Dunalley) had no surviving children and so the estate passed to a cousin, likewise called Peter Holmes. The family remained in ownership until 1865 when Petersfield and almost a thousand acres were sold to William Headech who seemingly moved to Ireland in the 1840s to act as

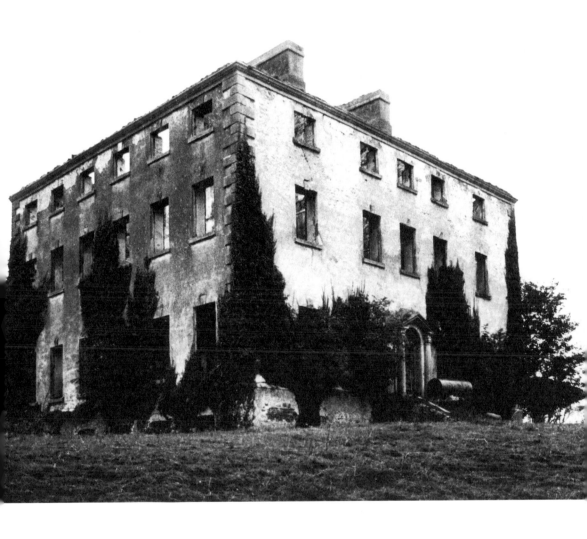

secretary to the Imperial Slate Quarry at Portroe, County Tipperary.
He subsequently bought the business and did so well that he was
able to pay more than £13,000 for the former Holmes estate.

His descendants remained there until the 1930s when the
Land Commission divided up the property, and the house was
unroofed. When Paddy photographed Petersfield it was still
standing, albeit in poor condition, but has since been demolished.

The Otways and the Wallers were two County Tipperary families descended from English soldiers who came to Ireland with the Cromwellian army and were rewarded for their services with a grant of land. Both subsequently prospered, their main seats being respectively Castle Otway and Castle Waller (both now ruins) and they intermarried in the eighteenth century. Around 1780 it is thought that James Otway, a younger son of the main branch, built Prior Park to the designs of amateur architect William Leeson. The latter is best known for laying out his native town of Westport, County Mayo, but he is also credited with a number of houses in the North Tipperary/East Galway region (where he lived) including Prior Park. Of three storeys over raised basement, the building is notable for the way in which the austere rendered façade's three central bays are tightly grouped together, leaving additional windows on either side looking rather adrift. In 1808 Prior Park was bought by George Waller, another younger son, and remained with his descendants until the 1980s. It is still in private hands.

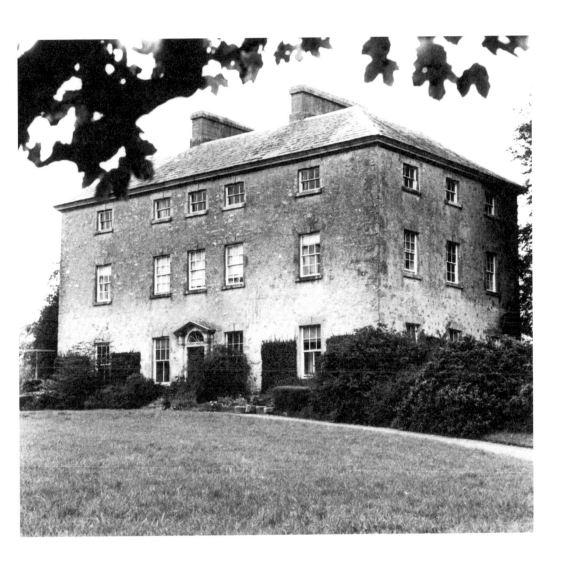

When Paddy photographed Favour Royal it was still owned and occupied by the family responsible for the building's construction, the Moutrays. They had come into possession of the lands on which it stands through marriage to an heiress in the seventeenth century, and a house was built around this time which survived until destroyed in an accidental fire in 1823. The following year John Corry Moutray commissioned the design for a new residence from Dublin architect John Hargrave. In style the building is typical of what was then in fashion, a harking back to the Elizabethan period that helped to suggest the owner had a long and distinguished pedigree. Although only of two storeys, Favour Royal is substantial and centred on a large staircase hall.

Following the death of the last family member in 1975 the house and what remained of the Moutray estate was offered for sale. The greater part of the land was acquired by the Forestry Commission but Favour Royal stood empty, a planning application for conversion to a hotel being allowed to expire without any work being undertaken: in 2011 it was badly damaged by arsonists. Since then the building has further deteriorated and although offered for sale some years ago its future looks uncertain, making Paddy's pictures all the more precious as a souvenir of what has been lost.

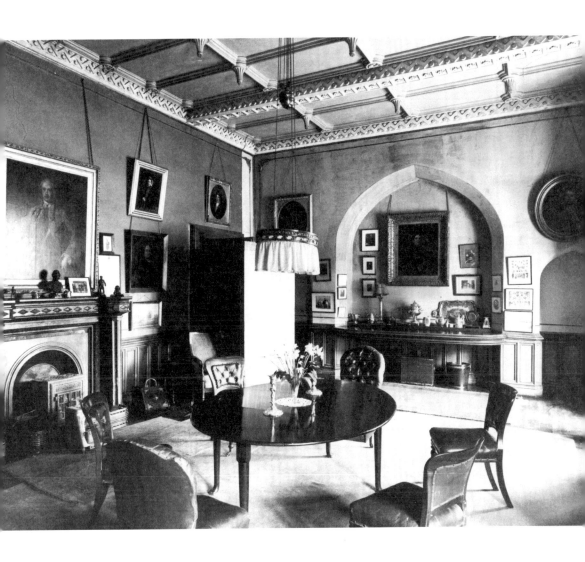

Although already in a state of some dereliction, Drumcree was
still inhabited when photographed by Paddy but has since fallen
into ruin. The house is one of a number built by members of
the Smyth family, originally from Yorkshire, who settled in this
part of the country in the seventeenth century: other properties
once owned by them include Barbavilla and Glananea. The estate
around Drumcree ran to almost 4500 acres, allowing successive
Smyths to represent Westmeath first in the Dublin and then the
Westminster parliaments, although the last to do so, Robert Smyth,
was described in the *Dublin Evening Post* in June 1826 as 'the most
stupid and silly man in the county'.

Drumcree dates from the mid-eighteenth century and
has been tentatively linked by Professor Christine Casey to the
Dublin architect Michael Wills. Of two storeys over basement,
its seven-bay limestone façade features three advanced and
pedimented centre bays in which a short flight of steps give access
to the doorcase beneath a segmental pediment. Directly above
is a Venetian window flanked by arched niches. Until recently
Drumcree was submerged beneath a dense quantity of vegetation
but this has been cleared away, suggesting the house might yet
return to domestic use.

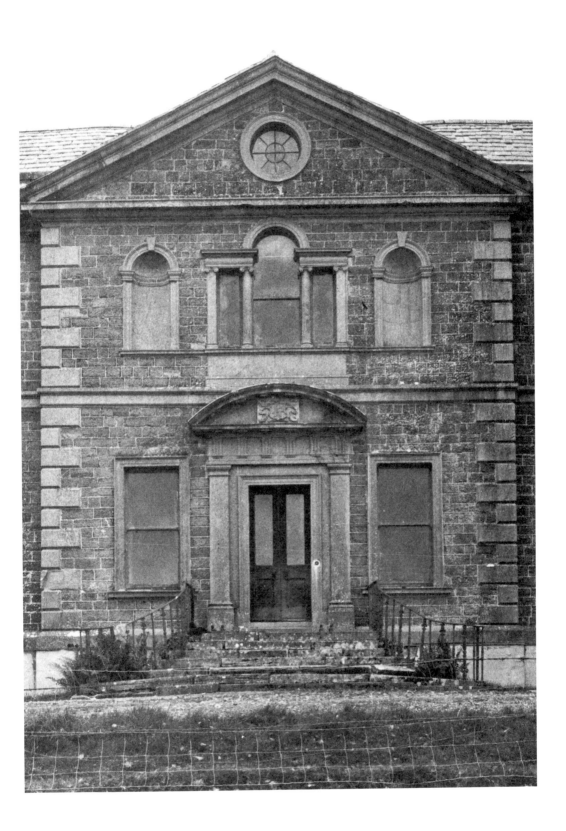

Killua was originally a typical classical country house of three storeys over basement with a bow-fronted saloon overlooking the demesne: a painting of it in this guise by William Sadler survives in a private collection. Then called St Lucy's, it was built *c.*1784 for Sir Benjamin Chapman who, having no children from his marriage, left the estate to his younger brother, Sir Thomas. In the 1820s the latter was responsible for transforming the house into a Gothic confection, the architect responsible believed to be James Shiel who would later execute similar work at Killeen Castle (*q.v.*) in neighbouring County Meath. The classical building was now cloaked in battlements, towers and turrets of limestone rubble, so that it resembled the castle that justified a change of name. The surrounding parkland was likewise embellished, not least by the erection of an obelisk commemorating the introduction of the potato to Ireland by Sir Walter Raleigh, who had been a cousin of the Chapmans. The property remained with the family into the twentieth century when the heir, Sir Thomas Chapman, deserted his wife and daughters for a nursemaid-governess called Sarah Lawrence: one of the couple's illegitimate children was T.E. Lawrence. Meanwhile Killua, inherited by a cousin, was sold and then resold, and gradually stripped of its contents until even the roof was removed.

This is the condition in which it was photographed by Paddy, yet another gaunt ruin on the horizon. Remarkably in the present century Killua has undergone a renaissance, bought by enthusiastic owners who have been painstakingly restoring the building so that it is once more a family home.

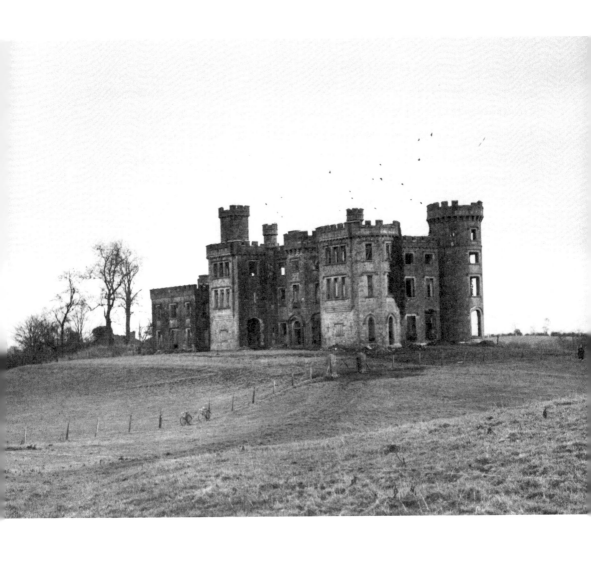

The triumphal arch marking the entrance to Rosmead, County Westmeath, is the best-known and most photographed feature of this property. Dating from the mid-1790s and thought to be the only work in Ireland by English architect Samuel Woolley, the arch originally belonged to another estate some seven miles away but was moved here in the nineteenth century. The house at Rosmead was built *c.*1780, a large and rather austere neo-classical block of three storeys and seven bays; some further additions were made in the second half of the nineteenth century to the designs of Sandham Symes. Within a hundred years, however, the place had been abandoned, the entrance porch removed to another house not far away. Long unroofed, Rosmead's remains can be seen across open fields from the aforementioned arch. Paddy's evocative photograph shows a pair of coach houses in the old stableyard to the rear: as so often, these survived longer and continued to be used long after the house had been abandoned.

Only five bays of the original seven-bay garden front survive to indicate the scale of Waterstown, built around 1745 to the designs of Richard Castle. The land on which it stands was originally owned by a branch of the Dillon family and supposedly they erected a castle here although no evidence of it survives. The estate was acquired in the middle of the seventeeth century by William Handcock, originally from Lancashire. It was his grandson Gustavus Handcock who, following marriage to Elizabeth, only daughter and heiress of Robert Temple of Mount Temple in the same county, embarked on building a new residence here. Of three storeys over basement and faced with cut limestone, Waterstown seems to have mostly impressed thanks to its scale. The architectural features were undistinguished and the surviving interior wall shows the remains of the period's standard plaster panelling. Passing through the female line on one occasion in the nineteenth century, Waterstown remained in the possession of Gustavus and Elizabeth Handcock's descendants until 1923 when the place was sold to the Land Commission. Thereafter the condition of the house quickly deteriorated, and in 1928 a new owner stripped it of anything valuable: the main Gibbsian doorcase went to another house while the principal estate gates can now be seen outside St Mel's Cathedral, Longford. A number of outbuildings and follies survive in the former demesne.

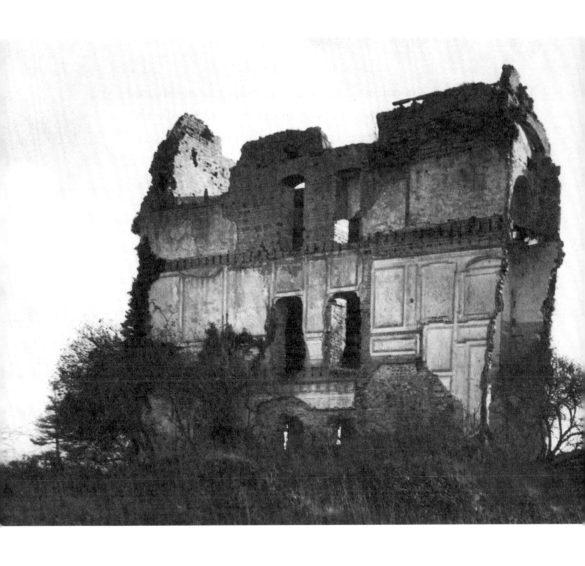

Today Avondale is best-known as the former home of Charles Stewart Parnell, but the man responsible for commissioning the house also deserves to be recalled. A barrister and Member of Parliament for County Wicklow, Samuel Hayes was a keen dendrologist who in 1788 presented a bill to Irish House of Commons entitled 'An act for encouraging the cultivation and better preservation of trees', and in 1794 published his *Practical essay on planting and the management of woods and coppices.* He put his knowledge of trees to practical use on the estate he had inherited from his father, and where *c.*1779 he built a new house, originally called Hayesville but later renamed Avondale. Since Hayes was also an amateur architect, it seems he had a hand in the design of the building, although a drawing exists of a house for Hayes by James Wyatt.

Like so many other Irish country houses of this period, the plain exterior gives little indication of the riches within, not least the dining-room, seen here, where the walls are elaborately decorated in neo-classical plasterwork incorporating oval mirrors and painted medallions. Hayes had no children and so on his death in 1795 he left Avondale to William Parnell, a younger son of Sir John Parnell, to whom he was related by marriage. William Parnell was the grandfather of Charles Stewart Parnell. The latter's brother inherited Avondale in 1891 but sold it soon afterwards: it was acquired by the state at the start of the last century and has since been used as a centre for the development of forestry. In January 2019 it was announced that €8 million was to be spent developing Avondale into a 'state-of-the-art visitor attraction'.

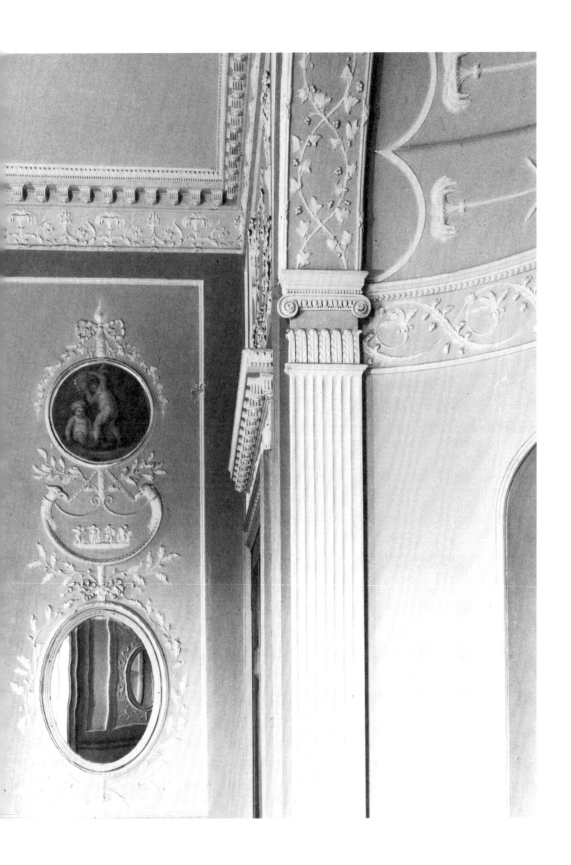

The Howards of Wicklow sometimes liked to claim an association with the family of the same name who were Dukes of Norfolk, premier dukes and Hereditary Marshals of England. In fact they originated in the area of Shelton, Nottinghamshire (whence would derive the eventual name of their family seat, Shelton Abbey, County Wicklow) and it would seem to have been after the death of one John Howard in 1643 that his widow Dorothea and their son Ralph firmly settled in Ireland. Ralph studied medicine and in addition to being one of the founders of the College of Physicians in Dublin also became Professor of Physic at Trinity College, Dublin. In turn his most ambitious son Robert would become a bishop of the Church of Ireland; it was his son, another Ralph, who built the new residence at Shelton and was also ennobled as Viscount Wicklow.

In its present form, Castle Howard was developed on the site of an older property by Colonel Robert Howard, a younger son of the third Earl of Wicklow. In 1811 he purchased from a house then called Cronebane Lodge romantically perched above the Meeting of the Waters, a spot made famous thanks to a poem written by Thomas Moore four years before. Its location, combined with the desire to build a residence evoking an ancient past, encouraged Col Howard to commission a design from architect Richard Morrison that would appear part-castle and part-abbey, 'to which the site is peculiarly appropriate'. The interiors owe much to the English Perpendicular style, not least the splendid staircase. Lit by a large arched Gothic window the cantilevered Portland-stone steps with brass banisters spiral up to the first floor below a plasterwork ceiling replete with coats of arms featuring families associated with the Howards. Although no longer with descendants of the original owners, Castle Howard remains in private hands and in excellent condition.

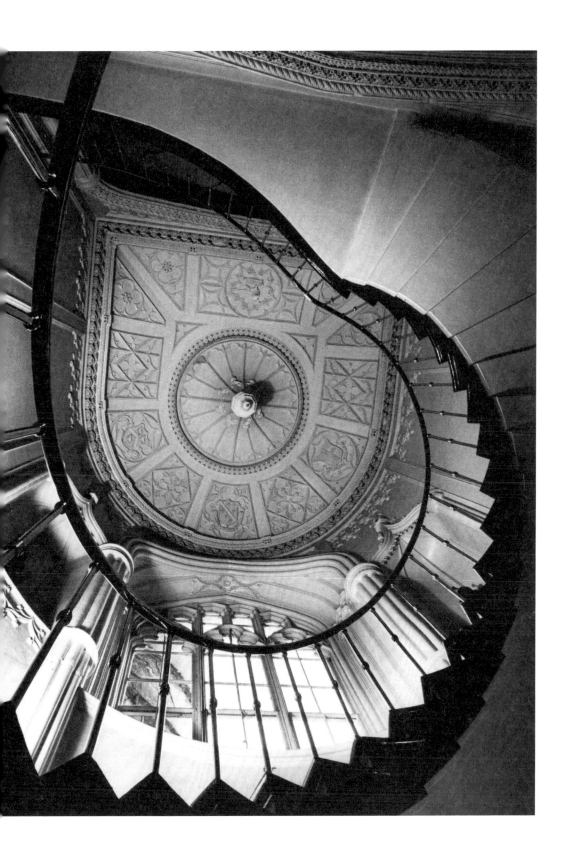

The Truells of Clonmannon were a clerical family, beginning with the Rev. Holt Truell (b.1701) who for many years served as both a rector and as justice of the peace. Despite marrying twice and having several children, he was outlived only by his younger son, the Rev. Robert Truell; it was either he or his own son, Robert Holt Truell who was responsible for funding a school in the vicinity of Clonmannon. By that date the family had moved out of the property seen here into a larger residence close by. Paddy's photograph shows the centrepiece of an earlier house, the date of its construction unknown. Stylistically the two-storey and three-block is indebted to the early seventeeth-century English architect Inigo Jones. On the other hand, its design has been attributed to Dubliner Michael Wills who was a cousin of the Truells, and a date of *c.*1755 proposed for its construction. Although the basement is of rubble stone, the rest of the building is in brick with a rusticated groundfloor and then pilasters on the upper storey supporting a pediment with an elliptical window at its centre. Originally it was flanked on either side by recessed three-bay wings with raised basements but that to the south was demolished in the early part of the last century and replaced with a single-storey extension, thereby giving the house an unfortunately lop-sided appearance. However, happily it still stands and remains in use as a private dwelling.

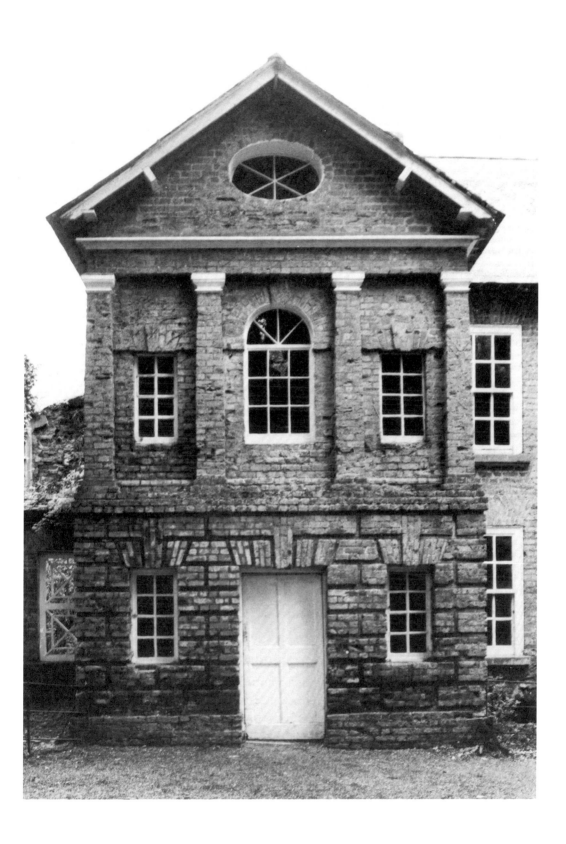

One of the greatest architectural losses of the last century, Powerscourt was accidentally gutted by fire in November 1974. The house incorporates a U-shaped castle, the original of which was built by a Norman knight, Milo de Cogan. His daughter married into the de la Poer family, and from their name Powerscourt gained its own. The castle appears to have been attacked, changed hands and rebuilt more than once before being granted in 1609 by James I, along with surrounding lands, to the military adventurer Sir Richard Wingfield. Powerscourt remained in the possession of his family (subsequently ennobled as Viscounts Powerscourt) until 1961 when acquired with the majority of its contents by the Slazengers: they had just concluded a major refurbishment of the property in anticipation of its opening to the public when the fire occurred.

Paddy's photograph shows the building's greatest room, the double-height first floor saloon. Like the other principal interiors this was designed by Richard Castle who took advantage of what had been an open courtyard between the two wings of the old U-shaped fortified house. Inspiration for the saloon came from the Palladian 'Egyptian Hall', in turn based on descriptions of such rooms in Vitruvius. The nearest contemporary equivalent are the Assembly Rooms in York designed by Lord Burlington (1731–32) but they were in a public building rather than a private residence. Thanks to the seventh Viscount Powerscourt, the saloon was further aggrandized in the second half of the nineteenth century by the addition of a monumental chimneypiece and Italian baroque chandeliers. Alas all vanished in the 1974 conflagration and it is only thanks to photographs such as this one that we have an idea of what was then lost.

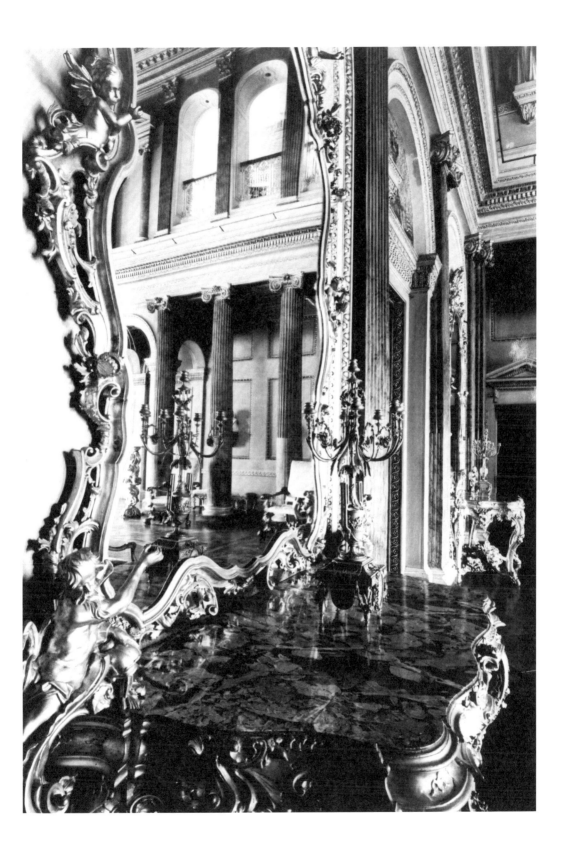